GHOSTS OF SOUTHWESTERN PENNSYLVANIA

GHOSTS OF SOUTHWESTERN PENNSYLVANIA

THOMAS WHITE

Published by Haunted America
A Division of The History Press
Charleston, SC 29403
www.historypress.net

Copyright © 2010 by Thomas White
All rights reserved

Cover Image courtesy of Shane Henderson.

First published 2010

Manufactured in the United States

ISBN 978.1.59629.923.8

Library of Congress Cataloging-in-Publication Data

White, Thomas.
Ghosts of Southwestern Pennsylvania / Thomas White.
p. cm.
Includes bibliographical references.
ISBN 978-1-59629-923-8
1. Ghosts--Pennsylvania. I. Title.
BF1472.U6W49 2010
133.109748'8--dc22
2010027411

Notice: The information in this book is true and complete to the best of our knowledge. It is offered without guarantee on the part of the author or The History Press. The author and The History Press disclaim all liability in connection with the use of this book.

All rights reserved. No part of this book may be reproduced or transmitted in any form whatsoever without prior written permission from the publisher except in the case of brief quotations embodied in critical articles and reviews.

In memory of Dolly and Ed Goslawski

CONTENTS

Acknowledgements	9
Introduction: Hauntings, Legend Trips and Memory	11
Ghosts and Curses at the Old Quaker Church: Fayette County	17
The Ghosts of St. Vincent Archabbey and College: Westmoreland County	24
The Specter of Summit Cut Bridge: Beaver County	34
Was the Asylum Haunted? Allegheny County	37
Mysterious Mudlick Hollow: Beaver County	43
Strange Happenings at West Overton: Westmoreland County	46
The Haunted History of the Evergreen Hotel: Allegheny County	51
Shades of Death Road: Washington County	56
The Ghost of Friendship Hill: Fayette County	58
The Deacon Is Watching: Allegheny County	61
Cries at the Black Cross: Butler County	66
Ghosts in the Cathedral of Learning: Allegheny County	69
The Gates of Hell: Fayette County	75
The Phantoms of Covert's Crossing Bridge: Lawrence County	77
Something Came with the Building: Allegheny County	80

Contents

Ghosts at the KKK House: Lawrence County	83
Who Walks at the Weitzel House? Allegheny County	85
The Ghost of the Old Shot Tower: Beaver County	90
A South Side Specter: Allegheny County	92
The Haunted House of Harlansburg: Lawrence County	94
Ghost in the Mill: Allegheny County	97
Moll Derry, Fortuneteller of the Revolution: Fayette and Bedford Counties	101
The Phantom at the Pond: Allegheny County	106
The Devil Takes the Wheel: Allegheny County	109
More Ghostly Graves and Haunted Cemeteries: Various Counties	112
More Haunted Colleges and Universities: Various Counties	115
Conclusion	119
Selected Bibliography	121
About the Author	127

ACKNOWLEDGEMENTS

Gathering these ghost stories and writing this book required the help and support of many people. I need to thank my wife, Justina, and my children Tommy and Marisa for allowing me to have the time to complete this project and for their encouragement. I also want to thank my parents, Tom and Jean, and my brother, Ed, for their support and advice. Many people passed along stories and information to me over the years and helped verify facts and details. Brett Cobbey and Dan Simkins introduced me to the legend of the haunted Quaker church almost fifteen years ago and have helped me to collect details of the story. Aaron Carson used his superb research skills to help me track down obscure articles. He also proofread the manuscript. Lauren Lamendola provided me with an incredible array of information about St. Vincent's College. John Schalcosky gave me enormous amounts of material on the Weitzel House and the Evergreen Hotel. Those sections could not have been completed without his help. My good friend Tony Lavorgne accompanied me on trips to many of the sites discussed in this book and photographed some of them. Once again, Michael Hassett gathered information and photographs for me in the New Castle area. Dr. Laurel Black, Nathan Jay Forbes and the rest of the Paranormal Society of IUP provided information about their investigations at West Overton. Elizabeth Williams, Paul Demilio and Renee Morgan took the time to

Acknowledgements

proofread this manuscript on multiple occasions. The staff of the library and archives of the Heinz History Center, especially Robert Stakeley and Art Louderback, was extremely helpful as usual. Many other people assisted me in a variety of ways, including Angela Wells, E. Maxine Bruhns, Faith Hoenstine, Aimee Zellers, Emily Jack, Heather Frazier, Kelly Anderson, Brian and Terrie Seech, Brian Hallam, Ken Whiteleather, Kurt Wilson and Vince Grubb. Also, I would like to thank Hannah Cassilly and the rest of the staff of The History Press for giving me the opportunity to write this book.

INTRODUCTION
HAUNTINGS, LEGEND TRIPS AND MEMORY

It seems that people are always fascinated by ghosts and hauntings. A good ghost story can frighten us and still draw us in. Over the centuries, ghosts have meant many different things to many different people. Every culture since the beginning of recorded history has attempted to make contact with the dead and otherworldly spirits. From the ancient Greeks to Renaissance necromancers, nineteenth-century spiritualists to modern ghost hunters, there have always been people who seek out those who have died before them. Though their reasons for doing so have changed drastically over the millennia, their quest to reach out to the dead has continued. Some sought knowledge or prophecy that only spirits could provide. Some were desperate for contact with lost loved ones or confirmation of an afterlife. Others have sought ghosts purely for entertainment, just to catch a glimpse of the unknown. Many were merely charlatans who manipulated people's belief in spirits for their own ends. Just as the motivations of the ghost hunters have changed, so have the motivations that have been ascribed to the ghosts that have allegedly appeared throughout history. Ghosts were said to have provided warnings or appeared to right an injustice. Some were sent by God to help, others by the devil to lead men astray. Certain ghosts guarded lost treasure. Other phantoms appeared at the site of their tragic demise, replaying the events of their death over and over. There are

Introduction

as many motivations for seeking ghosts (and ghosts seeking us) as there have been people watching for them. Despite all the technology, science and theory of the modern world, it seems as if there are more tales of hauntings than ever before.

While it is nearly impossible to easily summarize the importance of ghost beliefs in history, I can tell you why they interest me. There are actually a couple of reasons. The first is the element of mystery. Few things are as exciting as the unknown. Nothing describes this feeling better than the overused but very true quote by Albert Einstein: "The most beautiful thing we can experience is the mysterious. It is the source of all true art and all science. He to whom this emotion is a stranger, who can no longer pause to wonder and stand rapt in awe, is as good as dead: his eyes are closed." Even in the area of academia, where I spend most of my days, it can be just as important to "turn off" the theory and critical outlook and try to experience at least some elements of folklore firsthand. In my area of specialization, public history, I sometimes have that opportunity because archives and museums serve as a bridge between academic ideas about history and the general public. At that intersection, the forces of traditional history and popular belief interact. It allows an opportunity to understand the uses of folklore and history among the general populace.

That being said, the second reason ghost stories fascinate me is because of the history that they both reveal and conceal. Ghost stories, like any other type of folklore, can tell you a tremendous amount about the people recounted in them—but even more about the people telling them. Sometimes the tellers of such tales (us) project their interpretation of events, fears and beliefs backward into the past or into the stories. The stories can carry warnings and reminders of dangers past and present. Other times ghost stories can be a form of memory that is transmitted, usually orally at first, through the community rather than being recorded as part of the historical narrative. The stories can carry the memory of disasters, forgotten people or marginalized groups or events that had a large impact locally but are otherwise viewed as minor from the outside. Ghost stories in that sense are a form of popular community history. Though the exact details of events may become skewed, the core message or meaning of the story or memory is retained.

Luckily for those of us who enjoy folklore, southwestern Pennsylvania is full of ghostly tales. The region has hundreds of stories of hauntings

Introduction

that range from the vaguely rumored to the well documented. For the past decade or so I have been actively collecting the folklore of this region. During that time I found that of all the types of folklore in western Pennsylvania, ghost stories and urban legends were the most common. In my first book, *Legends and Lore of Western Pennsylvania*, I covered several well-known urban legends and hauntings, such as the Green Man, the ghost of St. Nicholas Church and others. *Legends and Lore* discussed a variety of other types of folklore as well. When it was completed, I still had dozens of interesting ghost stories that I could not include. As a result, I wrote the book that you are reading now.

In *Legends and Lore*, I made a distinction between ghost stories and urban legends. What I classified as ghost stories were generally unique tales of hauntings with historical—or at least based on historical—roots. Ghost stories also tend to have firm geographical ties to a specific building or location. Urban legends, on the other hand, tend to represent current societal fears and bear similarities to other stories around the country even though it may not appear so. They have questionable origins ("a friend of a friend") and have very frivolous, if any, ties to actual events. I focused on a specific type of interactive urban legend experience called a legend trip by modern folklorists. People who go legend tripping, usually adolescents or young adults, travel to a secluded but usually car-accessible area at night in search of some type of interaction with the supernatural. They usually perform some type of ritualistic activity such as flashing headlights three times or putting their car in neutral, etc., to trigger a supernatural response. In the process they complete a rite of passage and become part of the legend themselves. The tales in my previous book fell fairly clearly into these two categories. In this volume, some of the tales have multiple layers of hauntings and contain elements of both of my somewhat artificially divided categories. I have chosen not to divide these stories along the previously mentioned categories for this book, but I will make reference to them in the text. Several stories have also been included in which the source wished to remain anonymous for personal reasons or because the haunting occurred in a private home. I usually prefer to avoid anonymous stories for the benefit of the reader, but I have included these because they are very interesting.

What you choose to believe about the existence of ghosts is up to you. I will make observations about their meaning and their cultural and

Introduction

historical context, but I will not attempt to confirm or deny the existence of something that is essentially unverifiable—and I'm in no hurry to find out firsthand. Like many others, I have had strange experiences. Some were explainable and some were not. The difference between the natural and the supernatural can be a matter of perception rather than fact. I can give you an example from my own experience: Several times, when I was in college, I would awaken early in the morning and find myself unable to move. I literally felt paralyzed. Not only could I not move, but I felt as if there was a heavy weight on my chest. The first time that it occurred was frightening. After what seemed like an eternity (but was probably only a minute) I was able to move again. A few weeks later I had the same experience. This time, I saw a vaguely cloudy shape hovering right above me for a few seconds. I did some research and found that many other people had similar experiences. Some even saw the full body of an old woman or hag on top of them, crushing their upper body. What I had experienced was an example of what has been called the Old Hag syndrome or sleep paralysis. Essentially what happens is that your body and mind wake up from sleep at different rates. Your mind is still partially dreaming, though your senses tell you what you are experiencing is real. Your brain also has not signaled your body to begin moving. Naturally, many people have turned to a supernatural explanation for what they were experiencing, especially in premodern times. In his book *The Terror That Comes in the Night*, David Hufford collected and examined individual experiences with the Old Hag. He traced the phenomenon back through history and across cultures and found that the experience was common, though interpretations of the syndrome differed. While science can seemingly explain away most encounters with the Old Hag, there are still opposing viewpoints. There are those who feel that the explanation of sleep paralysis does not adequately explain all of the variations that have been reported about the Old Hag experience. One person explained to me that the Old Hag could be a clever trick used by evil spirits or demonic forces. By hiding behind something with a scientific explanation, these evil forces make the victim believe that they do not exist. This is an example of how, for many people, science and the supernatural exist side by side. My point being that there can be multiple levels of interpretation for these phenomena, and these multiple interpretations are not necessarily mutually exclusive for an individual.

Introduction

Each person approaches a ghost story or supernatural experience within their own frame of reference.

So, regardless of what you believe about ghosts, I hope that you enjoy reading the stories that I have collected here. At the very least, I hope that you learn a little about our region's history. Remember, if you decide to visit any of these places yourself, please be respectful of the property, ask permission to be there and do not trespass—and do not commit any acts of vandalism. Also, I would like to make a brief note on terminology. Generally I will use the terms ghost, phantom, spirit and specter interchangeably. Some writers and researchers have attempted to make specific classifications for each term, but I will not do that here. I do, however, only use the term apparition to refer to partial or full-body human appearance of a ghost.

GHOSTS AND CURSES AT THE OLD QUAKER CHURCH

FAYETTE COUNTY

The Providence Meeting House and Cemetery is located on Quaker Church Road, just off Route 51 in the town of Perryopolis, Pennsylvania. Created as an offshoot of the Redstone Quaker community, the meetinghouse served the Quakers of Fayette County until the 1880s. The first structure on the site was a wooden building erected by John Cope in 1789. In 1793, it was replaced with a more substantial stone structure with wooden floors, benches and two fireplaces. When the Quakers had stopped using the meetinghouse, it quickly fell into disrepair. In 1893, descendents of the original community had the structure disassembled and rebuilt using as many of the original materials as possible. Slightly smaller than the original, the reconstructed meetinghouse stands alone in the middle of the one-acre cemetery that sprang up around it in the 1800s.

Over the years the vacant meetinghouse, often called the Quaker church, and surrounding cemetery have spawned numerous supernatural legends. This is not unusual considering that historically churchyards have been considered some of the most supernaturally active places. The church looks particularly creepy at night. A lone building silhouetted against the sky, surrounded by graves and an ominous looking metal fence. One of the most prominent legends about the church involves a curse. Two different versions of the story exist. The first warns that written somewhere on the inside walls

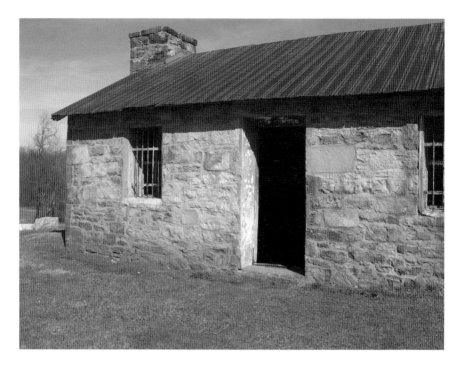

The old Quaker church near Perryopolis, Fayette County. *Courtesy of Tony Lavorgne.*

of the church is a message. It describes the tragic death of a young woman who is buried outside. If you happen to read the description, you will die the same way. The other version involves a cursed tombstone. If you read the message on the stone or step on it as you pass through, you will die or have a string of terrible luck. There are many tales of those who tested the stone only to find death and disaster. Allegedly, at least one young man who tested the legend was involved in a serious car accident within the week. Another man came home the next day to find his home engulfed in flames. Similar accounts are related throughout Fayette County.

One firsthand account that was given to the author described a trip by several college students to the church one Saturday night in the mid-1990s. The students had heard the legend of the cursed tombstone and decided to investigate it for themselves. After they arrived and passed through the gates of the cemetery, they located the stone. One of the men read the inscription, but nothing else seemed to happen. They looked around the eerie property and then went home. The next morning, the man who read

the tombstone went to church. When he returned home he saw firetrucks on his street—but not at his home. He soon received a phone call from a friend that had been with him the previous night and who happened to live just down the street. His car had apparently caught fire that morning. About a half an hour later, the man received a phone call from a friend who was attending Clarion University. He was back in Pittsburgh because his apartment burned in the middle of the night. A little while after that, the man received a call from the friend who had originally told him about the legend. His beloved dog had died. The man believed that the string of disasters might have been related to the curse. He believed that he had been spared because he had gone to church and received Communion early the following morning.

The stone that is usually associated with the legend belongs to Ella Mae Lynch (1861–1930) and William J. Lynch (1860–1932). The inscription reads "Remember youth as you go by, as you are now so once was I, as I am now so you shall be, beware for death and follow me." The inscription sounds ominous to those unfamiliar with old epitaphs, but it is actually a variation of a fairly common grave inscription from the 1700s and 1800s. The more common version reads "Remember me as you pass by, as you are now so once was I, as I am now so you will be, prepare for death and follow me." It was not meant to seem menacing but rather serve as a reminder of mortality and our brief time on Earth. To visitors unfamiliar with the epitaph, the tombstone seems threatening. Of course, if someone ever actually did place a curse on the stone, they left no record. (And I'm still not going to touch it.)

Other strange incidents have been reported at the site as well. For many years a story has circulated about a bizarre death related to the Quaker church. One fall morning in the 1970s, a man was walking his dog through the quiet cemetery. He began to hear whispers, and then he clearly heard the words "you're going to die tonight." The man was disturbed but convinced himself that it must have been a prank by one of the teenagers who would often hang out on the property. He heard no further noises and saw no one else, so he continued his walk. Just before he left the cemetery though, he heard it again—"you're going to die tonight." The man was shaken and went home and told his wife what had happened. He continued to try to convince himself that it was all a

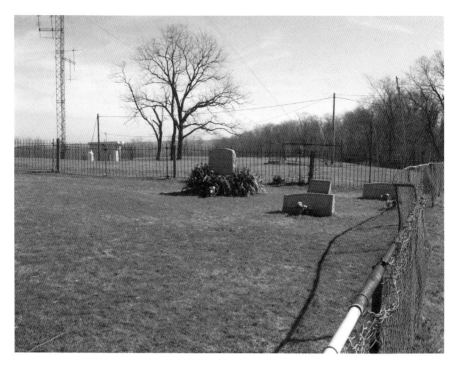

The cursed tombstone of Ella Mae Lynch. Legend says that if you touch the stone or read the inscription, you will be cursed with bad luck and possibly death. *Courtesy of Tony Lavorgne.*

prank or his imagination. The man went to work as usual and came home at the end of the day. The couple ate dinner and everything seemed to be normal. Afterward, the man went into the living room to watch the news while his wife cleaned up in the kitchen. About twenty minutes later the wife entered the living room to find the man slumped over in a chair. He was—of course—dead.

It is also commonly believed, despite a lack of historical evidence, that a witch was killed by members of the community on the site sometime in the 1840s. Her ghost supposedly inhabits the building, sometimes causing it to become unusually cold. While it is unlikely that there was an execution on the site, perhaps there may have been an accusation or rumor of witchcraft that entered into popular memory. There is another ghost that allegedly wanders the cemetery, pushing trespassers to the ground at night. The identity of the violent and protective ghost is unknown, but it is apparently unhappy when it is disturbed.

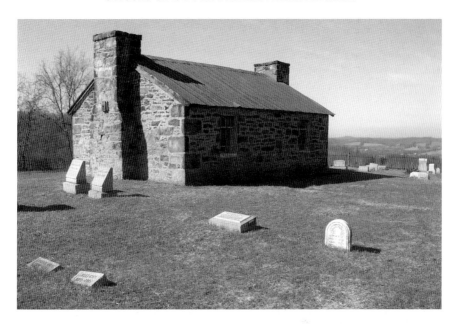

Another view of the Quaker church and part of the graveyard. *Courtesy of Tony Lavorgne.*

Strange happenings seem to plague the property. On one occasion, my friend visited the Quaker church during the day. What he found, though not necessarily supernatural, was bizarre. A fully grown deer was impaled through its neck on the metal fence. Most likely it had attempted to jump the fence and had miscalculated. Its lifeless body created a disturbing scene that almost seemed like an omen.

By the 1980s, there were rumors that the old meetinghouse was being used by a satanic cult to perform evil rituals and ceremonies. Allegedly some minor evidence of this cult was discovered, including strange writing, pentagrams and small animals that may have been sacrificed. Whether there was really a cult or just teenagers causing mischief and vandalism was never determined. The idea of a cult using the building seems to fit within the context of the Satanic Panic of the early 1980s. It was a nationwide scare over the alleged discovery of satanic ritual abuse, first in daycare centers in California and later in a variety of places around the country. Using now discredited methods like repressed memory therapy, a few psychologists and law enforcement officials claimed to have uncovered a vast satanic network with millions of members that were abusing and abducting children. Soon

evidence of these satanic cults was being uncovered everywhere from games and music records to bar codes on household products. The media covered the topic obsessively and implied that the claims had credence. Though the panic eventually subsided, it left a tremendous impression on the folklore and urban legends of the 1980s. Many new legends were created and satanic elements were added into existing ones.

The road in front of the Quaker church and cemetery has also been involved in the stories. One motorist was supposedly chased by a ghostly black dog in the late 1980s or early 1990s. It appeared beside the car as the driver slowed to look at the cemetery. Its menacing growl and glare filled the driver with fear, so he immediately drove away. The dog managed to keep pace with the car but suddenly vanished once it had reached the end of the property. Ghostly black dogs have a long tradition in British folklore. They often appear on desolate stretches of road near graveyards or old churches. They are described as fearsome with strange or glowing eyes

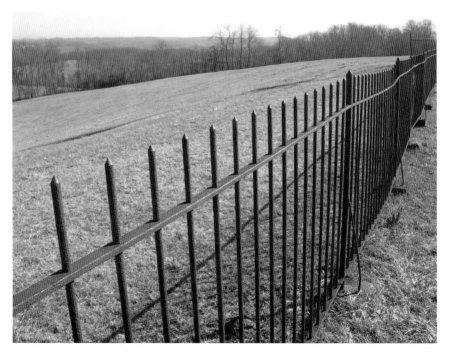

A fully grown deer was once found impaled on the pointed iron fence that surrounds the graveyard and church. *Courtesy of Tony Lavorgne.*

and are often considered to be the minions of witches or the hellhounds of the devil himself. The black dog at the Quaker church seems to fit firmly in this tradition.

Another driver who was passing the church had a frightening accident one night in the early 1990s. As he traveled past the property an old woman suddenly appeared in his headlights. He swerved to avoid her, but it was too late. The driver was sure that the car had struck her as he skidded off the road and into the brush. He immediately jumped out of the vehicle to help the woman but there was no one there. The man searched the road nearby, thinking that she might have been thrown from the impact. There was no trace of the woman. She had vanished as if she had never been there at all. It has also been said that if you drive in front of the cemetery late at night, the ghostly old woman may try to prevent you from leaving. If you shut your car off and then try to turn it back on, it will stall and the battery will seemingly go dead. When you look into the rearview mirror, you will see the old woman standing in the road behind you.

With the curse, the witch, the cult, the ghosts and the mysterious death, it seems that the Quaker church is one of the scariest haunted places in the region. For those of you who wish to tempt fate (and the phantom black dog) and visit the church, do so at your own risk.

And just remember, as you pass through the graveyard, watch your step.

THE GHOSTS OF ST. VINCENT ARCHABBEY AND COLLEGE

WESTMORELAND COUNTY

St. Vincent Archabbey, founded in 1846 in Latrobe, Westmoreland County, was the first Benedictine monastery in the United States. A Bavarian monk named Boniface Wimmer established the monastery and the associated college to train seminarians and missionaries to serve the needs of the large German Catholic community in southwestern Pennsylvania. He served as the monastery's first abbot. With the help of Bishop Michael O'Conner of Pittsburgh, Wimmer was able to purchase a tract of land known as Sportsman's Hall. On the property the monks constructed several buildings that formed the main living quarters of the community and classrooms for the students. In the 1850s, the Benedictines purchased some nearby property and built a gristmill and brewery. Food was grown in the large fields that surrounded the buildings. The goal was to make the monastic community self-sufficient. Years of prayer and hard work yielded a successful and ever growing institution. The monks of St. Vincent have fulfilled their mission of education and religious guidance ever since their arrival, overcoming numerous hardships along the way.

Like any historical institution, especially one associated with a college, St. Vincent has acquired a few ghost stories over the years. Some emerged from the growth of the monastic community and property. Others are campus legends that developed among the students. If all the stories are believed, it

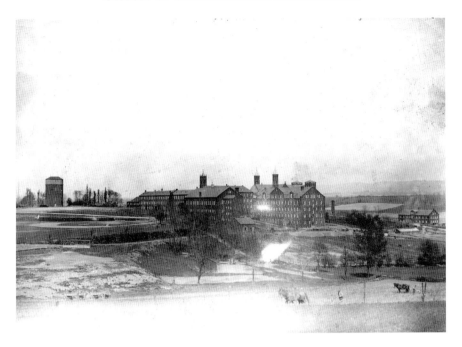

St. Vincent College and Monastery, circa 1900. *Courtesy of the Saint Vincent Archabbey Archives.*

can be argued that St. Vincent's campus and the associated properties are some of the most haunted in the state. The hauntings discussed here are just a few of the more prominent legends.

The early years at the monastery were filled with challenges and struggles and were not without controversy. There were outside complaints over the monks' production and sale of beer; nativist anti-Catholic and anti-immigrant sentiments were common; and conflict loomed on the horizon between the northern and southern states. The oldest ghost story at St. Vincent emerged around the time of the Civil War and was related to internal dissent within the monastic community. Ultimately the story was determined to be a hoax, but not before it had attracted interest from around the region and threatened to tear the monastic community apart.

The story begins with a young man from Rheno-Prussia named George Keck. He had arrived at the monastery during the summer of 1859 to study and enter into the novitiate. Keck had previously been a professional actor before deciding to devote himself to the monastic life. The twenty-three-year-old took the religious name of Paul. It was not long before the name

Paul Keck became synonymous with controversy. On September 18, Keck found himself lying in the infirmary because of illness. It was there that he claimed that he was visited by the ghost of a hooded monk who held a cross in one hand. The ghost stood and stared quietly; it is not clear how long the apparition lasted. Keck immediately told his superiors, and they believed his account to be authentic. Boniface Wimmer told Keck to attempt to talk to the apparition if it appeared to him again.

On November 21, Keck was with a priest when the ghostly monk returned. Though the priest saw nothing, Keck began to talk to the ghost. The phantom monk told Keck that his name was also Paul, and that he had died seventy-seven years before. The monk was in purgatory because of sins he "committed against monastic poverty." The ghost went on to say, "So far I have been allowed to appear every eleventh year, but until now all to whom I appealed refused to help." He asked Keck to have seven Masses offered, as well as a novena of nine days and a variety of other prayers. At this point Wimmer and other leaders of the community believed that Keck was having genuine visions, so the Masses and prayers were said. Allegedly, the phantom monk continued to appear to Keck throughout the end of that year. He also requested that they pray for the souls suffering in purgatory and mentioned that the five monks who had died since the founding of the monastery were also in purgatory. By the time the Masses had been completed, Keck reported another vision of the monk leaving purgatory for heaven.

By early the following year, word of the apparitions had spread to Pittsburgh. The February 26, 1860 issue of the *Pittsburgh Dispatch* ran an article about the ghost with a nativist–anti-Catholic slant. The article claimed that the ghost appeared to the entire congregation, stated that purgatory did not exist and that only two Catholic priests had ever gone to heaven. Whether the mistakes were intentional or not, Wimmer wrote to the paper to set the story straight. The *Pittsburgh Catholic* had a more accurate account of the story but a skeptical reaction, choosing not to give too much credence to the claims.

Meanwhile at the monastery, Paul Keck claimed to have received more instructions from the ghost. The monks were now to wear a rosary on their belts, suspend missionary work, change all of their middle names to Mary and engage in a more ascetic and contemplative lifestyle. The suggested

The original church at St. Vincent Archabbey. *Courtesy of the Saint Vincent Archabbey Archives.*

changes caused a rift in the community. Some of the supporters of Keck may have been pushing their own reforms and used him as a catalyst. The more traditional Benedictines rejected the proposed changes. At that point Wimmer still believed that Keck's visions were authentic but was unwilling to put an end to their missionary work. He found himself caught between the competing factions within his own monastery.

The traditional faction had the upper hand by 1861, and Keck was dismissed from the monastery. His exile did not last long. After receiving outside support from other affiliated monasteries, Keck found himself reinstated and receiving his minor orders in Latrobe in April of 1862. He still retained a substantial amount of support in the monastery, but he soon made a critical mistake. Keck informed Wimmer that the ghost appeared to him again in a vision, telling him to request ordination. Given that Keck was not even close to that important step, Wimmer refused. Keck then accused Wimmer and his associates of doing the work of the devil. He set off to Pittsburgh to try to convince Bishop Michael Domenec to ordain him. The bishop also refused, so Keck headed to the Diocese of Erie.

While waiting to gain an audience with Bishop Young of Erie, Keck attended a party at a private home. After the party, Keck and another priest walked back to St. Mary's Priory where he had been staying. Keck made homosexual advances toward the other man and attempted to seduce him.

The other priest was enraged and told not only his community of Keck's actions but also told Bishop Young and Boniface Wimmer. Keck attempted to blame the other priest, claiming that he was drunk, but Wimmer now saw through his deception. After a series of investigations, Wimmer discovered that many of Keck's supporters that sought to implement his ghost-inspired reforms were part of a homosexual subculture at the monastery, and Keck had made advances toward other monks. Wimmer, who once believed in Keck's visions, was now shocked and angry at the violation of the monastic vows of chastity and obedience. Both Wimmer and Keck's supporters took the issue to Rome. Some monks who had personal issues with the way that Wimmer ran the monastery supported Keck and thought that his encounters with the ghost, whether real or not, would bring changes. After several years of arguments it was decided that Keck's claims had no merit. His supporters were reprimanded, and Keck was banished from the monastery and was not heard from again.

Another, though less documented, ghost is said to haunt the Saint Vincent gristmill. The three-story mill was constructed by the monks in 1854 as part of Boniface Wimmer's plan to make the monastery and college self-sufficient. The mill used three-ton French quartz stones to grind the wheat that was grown in the archabbey's fields into flour. The gristmill was powered by the latest technology of the day, the steam engine, as opposed to water like many other mills. Changes have occurred to the mill over the years, but in many ways it is still the same. In 1952, electric motors replaced the steam engine as the source of the mill's power. The structure was added to the National Register of Historic places in 1978. By 1998, extensive restoration work was started on the gristmill, and it was mostly completed by 2000. The mill is still in operation today.

Many lay brothers have served as millers since the beginning, all doing their best to keep the building and machinery functioning properly. Over the years, there has been only one major accident. On January 24, 1862, Brother Majolus Kreutinger was killed in the mill. Somehow, he became caught in one of the long leather belts that moved the machinery. It is claimed that his ghost still haunts the building and can be occasionally seen or heard still performing his duty as a miller.

Legends surround another structure on the monastery grounds known as the Sauerkraut Tower. Constructed as part of the monastery's water system

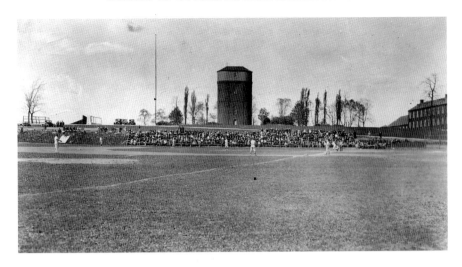

Sauerkraut Tower in 1926. *Courtesy of the Saint Vincent Archabbey Archives.*

in 1893, the ninety-six-foot high elliptical brick structure served as a water tower capable of storing up to seventy thousand gallons within its tanks. You might wonder how a water tower received such a strange name. The lower levels of the tower were cool and dark, and Brother Innocent, the chief cook, thought that it would be a good place to store barrels and crocks of sauerkraut as well as some of the cabbage grown on the farm. It was not long before the strong smell emanating from the tower became permanently associated with it. Even though the practice ceased sometime in the early 1900s, the name Sauerkraut Tower remained. After 1942, city waterlines reached St. Vincent, so storing water in the tower was no longer necessary. The building was then used for storage. In 1976, it lost sixteen feet off of the top when the water tanks were removed and the roof replaced.

A strange ghost story is associated with the tower, and it has circulated among students at the college for quite some time. It is commonly believed that a monk was obsessively constructing a windmill at the top of Sauerkraut Tower in the early twentieth century. One day while working on the machinery, his clothing became caught and he was strangled to death. His ghost can supposedly be seen looking out the windows near the top of the building. A mysterious blue light has also been seen spinning around the outside of the tower. The problem with this legend is that a windmill was never constructed as part of the tower. The ghost story may represent a

misremembering of the elaborate cork-float and pulley gauge system that was designed by Brother Victor in the 1930s to monitor the water level in the tanks. The pulley system saved Brother Victor the hassle of walking up ten flights of stairs to the top of the tanks to check the water level three times a day. Fortunately Brother Victor was never caught and strangled in his own pulley system. Through repeated retelling, the story of the pulley system may have taken on supernatural elements once the unique and potentially creepy tower was no longer used.

A rather disturbing story is told about Wimmer Hall, which houses students. Several decades ago a seemingly healthy student collapsed in one of the showers. Depending on the version of the story that you hear, he either had a heart attack brought on by some unknown medical condition or merely slipped, fell and hit his head. As he fell, his body bumped against the faucet and turned the hot water up the whole way. Hours went by before someone found the unfortunate student. By then it was too late. Not only was the student dead, but parts of his flesh had been scalded away after being subjected to the extremely hot water for such an extended length of time. Some of it had gone down the drain into the pipes. After the tragedy, the drain and all connecting pipes were replaced.

A year after the accident, another student who was staying in the same room filed a complaint because his drain had backed up. Facilities personnel could not get the drain to clear, so they removed the pipe to find the problem. To their horror, they found that the drain was clogged with flesh. No one could explain how it happened, and all the pipes were replaced again. Supposedly the drain still mysteriously clogs to this day. Of course verification of this legend is difficult to find. Elizabeth Tucker, who has written extensively on campus folklore, has noted that college ghost stories tend to have shocking sensory images. That is certainly the case with this story. It may, in fact, be a variation of the haunted faucet legends that Tucker has identified on several college campuses around the country. This legend type involves faucets or other pieces of plumbing turning themselves on or off or mysteriously not working. Water pressure and plumbing issues, common in residence halls, are explained away with a possible supernatural angle. If that is indeed the case with this legend of Wimmer Hall, it is certainly one of the most graphic.

Another story of a mysterious death and strange happenings is associated with Aurelius Hall. At least part of the legend is tied to a real fire that destroyed

the top of the building. On April 29, 1976, a fire erupted on the seventh floor. According to the legend, it was no normal accident. A secretive freshman who lived on the floor was said to be a devil worshipper or cult member. That April night he had decided to perform a dark ritual. In preparation for the evil ceremony, he had surrounded himself with candles. At some point during the ritual it seems that the young man knocked one or more of the candles over and the fire ignited. The flames burned very intensely but remained mostly contained to the seventh floor. The situation became even more bizarre when the fireman finally reached the student. Despite the fact that the entire room around him was burnt, his body was still intact. When the fireman touched the freshman to check for a pulse, he burned his hand as if he had touched a hot piece of metal. The student was dead, and his body eventually cooled. No one could explain how it survived the fire. Was it the work of the devil? The 29th was the night before Walpurgis Night, an ancient pagan holiday from Central and Eastern Europe. The Germans believed that it was the night that witches would gather to prepare for the spring and perform ceremonies. Was the student performing some type of preparatory ritual?

Since that time, a variety of strange occurrences have been reported on the upper floors of the building. They include unexplained noises, electronic devices turning themselves on and objects changing location seemingly on their own. Students have heard footsteps and movement in the dorm rooms on the upper levels, especially at night when they are in bed. Some students have even reported seeing partial or full apparitions pass through their rooms or hover silently near their beds.

Several versions of the story exist with slight changes in details. Currently, the seventh floor of Aurelius Hall is an attic used for storage and has no dorm rooms. (The sound of footsteps in the attic is still reported.) The sixth floor has dorms, and is in reality the seventh floor because the building has a ground floor. When the floor is mentioned in the legend, it is not clear which one is being referenced. There does not seem to be any evidence that a student was actually killed in the fire. Given the date and the fact that the legend probably developed in the decade after the students who were there at the time graduated, it appears that it fits within the timeline of the previously mentioned Satanic Panic of the early 1980s. Legends of cult or ritualistic activity were just as common in academic institutions as they were

The cemetery at St. Vincent. *Courtesy of the Saint Vincent Archabbey Archives.*

elsewhere. Even if the story did begin to develop before the panic, the late 1970s saw much more popular attention paid to occult topics and alternative religions. The media attention in the eighties added fuel to this legend's fire.

St. Benedict's Residence Hall also has a ghost. The spirit of a young girl allegedly wanders the halls and dorm rooms. Her origin and real identity are unknown. Some of the students have given her the name Jenny. The little girl's ghost has the habit of borrowing the resident's belongings. Items will disappear for weeks or even months, then mysteriously reappear. (I wonder if anyone has ever used the "ghost stole my paper" excuse.) Jenny can also be heard wandering the halls and giggling at night when everyone is in their rooms or asleep. Tiny handprints have even appeared on the *outside* of the fifth-floor windows.

Other campus legends involve the graveyard on the hillside behind some of the residence halls. Several strange occurrences have been reported among the graves. The graveyard is the final resting place for members of the monastic community and also some of the members of the local community whom the monastery served in the early years. Two of its stories involve statues. One statue of Mary will allegedly cry tears of blood when a suffering person approaches her to pray. The other statue is a Pietà (a statue depicting Jesus in Mary's arms after he was taken down from the cross) in the middle of the graves. If a student sits down on the bench in front of the statue and stays for a while, Mary will raise her head and look at them. A young boy's ghost has also been seen walking around the graveyard. He disappears near a gravestone next to a large tree stump that is carved into the shape of a chair. Sometimes he can be seen sitting or climbing on the stump.

Of course our survey of St. Vincent's ghosts would not be complete without discussing the spirit of Boniface Wimmer himself. Every year when Founder's Day is celebrated just before Thanksgiving, his ghost reportedly returns to inspect the campus. At midnight he leaves his grave and walks his beloved campus and monastery for an entire day, passing through every red door. He ends his journey at the red doors to the crypt below the basilica, where he says Masses for people that he was not able to finish before he died. The alleged visitation of the ghost of Boniface Wimmer is a reminder of both the history and origin of the institution and a representation of the extreme dedication of the early monastic community.

THE SPECTER OF SUMMIT CUT BRIDGE
BEAVER COUNTY

Summit Cut Bridge, often incorrectly referred to as Summer Cut Bridge on the Internet, stretches above the tracks laid by the Pennsylvania Railroad decades ago, not far from Beaver Falls. It was built to connect the roads and neighborhoods that were severed by the rail line and the ravine it created. The current bridge was constructed in the early 1970s to replace the previous one that had been there for a century. The old wooden bridge, which was 110 feet in length, had been very narrow and was the site of numerous accidents. As a result, stories of a strange specter at the site of the bridge have circulated over the years.

Several versions of the legend have been told, but the most common involves a young woman who was involved in a tragic automobile accident. It supposedly happened late one night in the 1940s or 1950s during a severe thunderstorm. The young woman was on her way home and was having a difficult time seeing the road because of the torrential downpour. As she made the sharp turn onto the bridge, she failed to slow down sufficiently. Her car slid out of control, crashed through the guardrail and plunged ninety feet into the ravine below. The woman was killed. The accident was only discovered the next morning when the sun revealed the grisly wreckage.

Since that time, strange occurrences have been reported on both the old and new bridges. Some motorists who have happened to look down at the

tracks below during rain or a storm have reported seeing a ghostly woman standing near the site of the accident. A more threatening version of the specter has materialized on both the old and new bridges. After appearing suddenly, the ghostly woman attempts to misdirect drivers off the side of the bridge or down the steep embankment by motioning with her arms. A pair of phantom headlights has also been spotted, swerving erratically before vanishing.

Reports of encounters with the ghostly woman still occur on such a regular basis that one might wonder if there is any substance to the story of the accident. In truth, there were numerous automobile and pedestrian accidents on the old bridge, though none seem to exactly match the standard version of the ghost story. One of the first officially recorded accidents at the bridge occurred in September of 1891. An elderly man from Pittsburgh named P.D. Menone was struck by a train near or under the bridge. Apparently he had been walking too close to the tracks. In 1894, a young woman was walking on the side of the narrow bridge, lost her balance and fell to her death. On the evening of April 5, 1937, a car carrying sixty-three-year-old William Frethy and thirty-four-year-old Mabel Freed crashed through the guard cable and plunged off the bridge. Both were killed upon impact. Mrs. Carl Gregg had a similar accident in 1950. The forty-one-year-old woman also drove off the bridge at night in nearly the same spot. The newspaper accounts noted that she had been in ill health for fourteen years. She left behind a husband and children. Her tragic story most closely resembles the ghost story, given the fact that she was a woman driving alone at night. Perhaps it was the original inspiration for the tale.

The bridge was not yet finished claiming lives. On May 26, 1952, another couple had fallen victim to the dangerous conditions. Mr. and Mrs. Clarence D. Ault were turning onto the bridge when Mr. Ault lost control of the car and slid off the side. Their car had left the bridge about fifteen or twenty feet from the beginning and had taken out almost thirty feet of guardrail. The Aults' estate sued the railroad and Beaver County on their children's behalf in 1955 because of the unnecessarily dangerous conditions. Even before the lawsuit was filed, however, the bridge was renovated to prevent further accidents. It was widened from fourteen to twenty feet, and the sharp curve on to the bridge was eliminated. Forty-four-thousand dollars were spent on the improvements. By 1971, the original bridge was in such bad shape that it

needed to be completely replaced. Newspaper articles from the time of the construction of the new bridge seem to imply that there were many more accidents at the bridge in the past.

So is the bridge really haunted by the ghost of some tragic victim of a decades-old accident? Many people seem to think so; especially those who have encountered something strange while crossing over. On the other hand, the story could be a community memory that recalls the horrible accidents and dangerous conditions that plagued the bridge for years. The repetitive tragedies seared itself in the collective memory of the area. Perhaps it is both. Either way, if you are ever inclined to go and visit Summit Cut Bridge late one night, don't ask any strangers for directions.

WAS THE ASYLUM HAUNTED?
ALLEGHENY COUNTY

Not many places in western Pennsylvania ever seemed as creepy as the abandoned Dixmont State Hospital in Kilbuck Township. Before its demolition in late 2005, the decaying mental-health facility stood on the heavily wooded hillside above Route 65. The asylum was eerily isolated from the surrounding communities, even though they were not that far away. The entire place seemed to belong in a horror film. It even had a cemetery and dark underground tunnels. Since the hospital's closure in 1984, it had been attracting curious passersby, urban explorers and ghost hunters. As the structures on the property became more run-down in the 1990s, partially as a result of vandalism and fire, the site seemed to draw increased attention. Dixmont soon gained a reputation as being one of the most haunted places in the region. Ghost hunters, psychics and others seemed to believe that there was substantial paranormal activity at the asylum. But was Dixmont really haunted by the ghosts of former patients? Were there any legends associated with the place before it became a creepy abandoned hospital? Or did Dixmont just seem like it should be haunted?

Dixmont State Hospital was the first hospital for the mentally ill in western Pennsylvania and one of the earliest in the state. The hospital began as the Department of the Insane in the Western Pennsylvania Hospital of Pittsburgh. The basic facilities, including the main Kirkbride

building (Reed Hall), opened in 1862. Though it is commonly believed that the hospital is named after Dorthea Dix, the social reformer who led the push for better facilities and treatment for the mentally ill, she insisted that it be named in memory of her grandfather (who was also named Dix, of course). The hospital was the most advanced of its kind, using what were then the best techniques to treat those who would otherwise be locked away in basements or attics or confined to prison. In those days, the institution treated people with problems ranging from alcoholism, bipolar disorder, post-traumatic stress disorder and postpartum depression to dementia, schizophrenia and brain tumors. These ailments

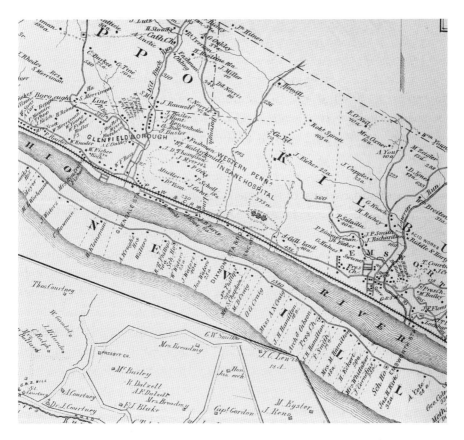

A map from the 1876 *Centennial Atlas of Allegheny County* that shows the property of Dixmont in Killbuck Township. The hospital is identified as the "Western Pennsylvania Insane Hospital." *Courtesy of the Library and Archives Division, Senator John Heinz Pittsburgh Regional History Center.*

were not necessarily recognized as the individual disorders or illnesses that they are today. The clean and well-kept grounds and buildings provided a tranquil atmosphere for the patients who forfeited all rights upon entering. It also provided comfort to families who secreted loved ones to the institution for fear of the stigma attached to those viewed as insane or mentally disturbed.

The hospital attempted to remain as self-sufficient as possible. Patients were all given a job or task if they were capable—cooking, cleaning, sewing, maintenance, etc. The administrators felt that this helped them maintain focus and have a sense of accomplishment. Male patients were kept in one wing and female in another. The methods used to treat some of the most severely affected patients may seem bizarre or perhaps even barbaric today, but most of the doctors were legitimately trying to help. In the late 1800s, hydrotherapy (cold and hot water baths), sensory deprivation and spraying with hoses were common. Later, in the 1940s and 1950s, electroshock therapies, lobotomies and full restraints were employed to modify the behavior of the worst patients. Electroshock therapy, though controversial, is still used occasionally today by a handful of doctors. It was used to treat a variety of disorders at that time. Besides being unpleasant, the therapy seemed to have the side effect of memory loss. Lobotomies were a more radical and invasive form of treatment. Originally, a surgical procedure was performed on the frontal lobes of the brain to modify behavior. This type of procedure had to be done at a hospital. Transorbital lobotomies, also known as ice-pick lobotomies, were faster and could be done in institutions like Dixmont. These ice-pick lobotomies involved accessing the brain through the eye sockets and severing some of the nerves that connected the frontal lobes. Using that method meant that there was virtually no permanent scarring or holes in the skull. Even though the procedure may have lessened psychotic symptoms, it often left the patients changed, debilitated and a vegetable at worst. By the 1960s, new antipsychotic drugs became the primary method of treatment for mentally ill patients. They proved to be more humane.

Ownership of the hospital changed over the years as well. In 1907, Dixmont became independent of the Western Pennsylvania Hospital. After several years of financial trouble during the Second World War, the state took over operation of the institution in 1946. As the twentieth century

Reed Hall at Dixmont State Hospital, 1946. *Courtesy of the Library and Archives Division, Senator John Heinz Pittsburgh Regional History Center.*

progressed, treatment of the mentally ill changed dramatically. Patients were granted more rights, and it became more difficult to admit someone to a mental institution. New drugs treated many disorders at home. Patients were no longer allowed to work without pay in facilities like Dixmont as well.

State budget problems in the early 1980s also hit Dixmont hard. In 1984, after 122 years, the hospital closed its doors.

In the intervening years between closure and demolition, Dixmont acquired its spooky reputation. The fact is, however, that in all its years of operation, there was never any recorded story or oral tradition of ghosts at the asylum. Many paranormal investigators have claimed to have witnessed or experienced strange happenings on the property, such as doors closing themselves, strange sounds and capturing orbs in photographs, but all of these can have practical explanations. Despite all the talk, there was still no real ghost story associated with the hospital.

Until the landslide, that is.

The seventy-five acres that remained of the property were purchased by a developer in 2005. The plan was to tear down the structures and build a shopping plaza that would include a Walmart Supercenter. By 2006, the buildings were razed and the property was cleared with the exception of the cemetery. Work crews were in the process of leveling the land when the slide occurred. On September 19, the hillside gave way and half a million yards of earth collapsed onto Route 65 and the railroad tracks that ran parallel to the road. It took weeks to clear the road, and it was not long before it was suggested that the angry ghosts of Dixmont had caused the slide. A second slide not long after seemed to confirm the idea for many who had already disapproved of the building project. Landslides in the area were not new, and the hospital had dealt with several in the early years, but this one seemed particularly ominous for some. After a year of failed attempts to stabilize the property, Walmart finally abandoned its plans to build on the site. For now the property will remain vacant and be reclaimed by nature. The only remnants of Dixmont are the rows of numbered tombstones that mark the graves of the deceased patients whose bodies had never been reclaimed by their families. Dixmont was their only home.

Perhaps there is another reason that Dixmont, like so many other abandoned mental hospitals and asylums, was assumed to be haunted. In many of the haunted asylum tales it is implied that the spirits of the deceased patients linger in this world because of the mental anguish that they suffered. What is unclear is whether the anguish was caused by their illness or from their now archaic medical treatments and social isolation. Maybe the tales

of the haunted asylums and their angry ghosts actually represent a sense of collective guilt over the treatment that the mentally ill endured over the previous centuries. Their plight is kept alive through the stories as both a remembrance and a cautious reminder that even the best intentions can have unintended consequences.

MYSTERIOUS MUDLICK HOLLOW
BEAVER COUNTY

Mudlick Hollow is located just outside of Vanport in Beaver County. For decades, stories have been told about strange noises and weird happenings in the hollow's lonely woods. Some of the legends that are recounted about the area stretch back to the earliest days of Vanport and before. The town itself was laid out along the Ohio River by Thomas Boggs in 1835. He had hoped that the location would help it become a bustling town. Ultimately, things did not turn out exactly as he planned, but the town did find some success with pottery and mining. A pier was constructed at the mouth of Two Mile Creek so that a ferry could operate on the Ohio.

One of the ghost stories is tied to one of the early residents. Patrick Mulvanon was a successful young man who operated a lime kiln in town. He was engaged to the lovely Anna Mines. As a gift for his fiancée, Patrick decided to construct an elaborate mansion. He chose a site in Mudlick Hollow for their new home. The mansion, which was completed in 1846, had three stories, white pillars, large fireplaces, a ballroom and an intricately carved wooden staircase. Anna loved her future home but, unfortunately, she never had a chance to live there. One day as Patrick watched, Anna tripped and fell down the staircase. By the time she hit the bottom, her neck was broken. After the initial shock, Patrick broke down and wept uncontrollably. He was never the same again. Supposedly he would wander aimlessly in the hollow, crying and mourning the death of Anna. It was said that he eventually sold the mansion and moved back to the town of Beaver, though

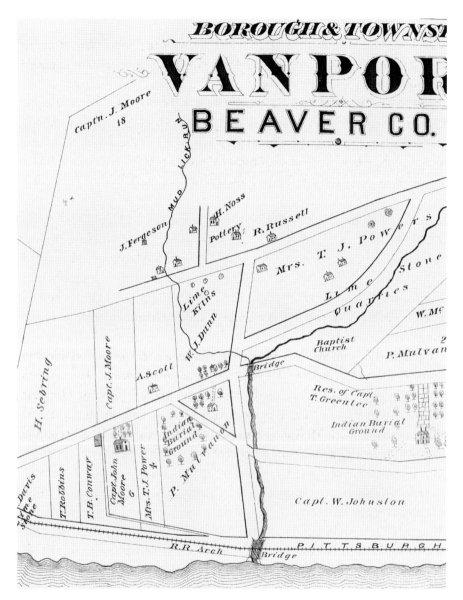

A map of Mudlick Hollow from the 1876 *Centennial Atlas of Beaver County*. Note that an Indian burial ground is located on Patrick Mulvanon's property near his house. *Courtesy of the Library and Archives Division, Senator John Heinz Pittsburgh Regional History Center.*

this had not been verified. If you wander through the hollow late at night, you are supposed to be able to hear Patrick, still weeping over his fiancée's untimely death.

Years later, another tragedy allegedly occurred involving a young couple. The unnamed newlyweds were riding through the hollow in their horse-drawn carriage on their wedding night. They were on the way to their new home in the hollow when they got lost on the dirt roads in the dark. Some kind of noise spooked the horses, and the carriage ran off the road and tumbled down into the creek below. The bride's bones were crushed under the carriage and her neck broken. The groom was also crushed, but he clung to life for several hours before his injuries claimed him. It has been suggested that it may have been the weeping ghost of Patrick Mulvanon that caused the accident. Perhaps his ghost was even jealous of the happy young couple. On foggy nights, the carriage can still be heard riding through the hollow. As it approaches, one can hear the noise of the crash and the screams of the dying couple.

Though the sad story of the couple makes an interesting addition to Mudlick Hollow's lore, to date the actual names of the couple have proven elusive. Did they really meet a terrible fate in the woods in the dark of night? Did they even exist at all? The story could be an embellishment of the earlier tale of Patrick Mulvanon and Anna Mines, with the facts becoming slightly jumbled over time with every retelling. Both stories contain a young couple who are about to get married or just got married, but their time is cut tragically short. Also, in both tales, the young woman breaks her neck. It is possible that different versions of the same story developed over time. Of course the couple may have been very real and just slipped through the often wide cracks in the historical record. We may never know for sure. That is, unless you plan on spending some sleepless nights in the haunted woods of Mudlick Hollow.

STRANGE HAPPENINGS AT WEST OVERTON
WESTMORELAND COUNTY

The historic village of West Overton is located along Route 819 just outside of Scottdale, Westmoreland County. The village is unique because it is one of the last preserved pre-Civil War industrial villages in the nation. The land was originally purchased by Henry Overholt, a Mennonite from Bucks County, in 1803. The 260 acres along Felgar Run proved well-situated for agriculture. Besides farming, Henry also began to make whiskey in a simple log distillery. His whiskey eventually bore the label Old Overholt Straight Rye Whiskey. Overholt's son, Abraham, also had many talents. He was a master weaver, a Mennonite bishop and turned the production of the family's whiskey into a profitable commercial venture. He constructed a new distillery and produced Old Farm Pure Rye Whiskey. Though both labels had the same recipe, the Old Overholt name was given only to the whiskey produced at the family's other property near Connellsville, while the Old Farm Rye label was exclusively associated with West Overton. To support the production of the whiskey, a small town grew up around the distillery on the Overholt property. West Overton became virtually self-sufficient, producing everything necessary to make whiskey and supply the townsfolk. The industrious nature of the village would have a tremendous impact on one boy who grew up there. In 1846, Abraham hired a man named John Frick to run the town gristmill. Frick quickly fell in love with Overholt's daughter,

Elizabeth, and they were married the following year. Their son, Henry Clay Frick, was born in 1849 in the springhouse next to Abraham's home. Henry Clay Frick spent the first decades of his life learning about business in the village. He applied those lessons later in life to dominate the region's coal and coke industry and to eventually partner with Andrew Carnegie to run the Carnegie Steel Company. It was Frick's daughter, Helen, who purchased and preserved the remaining property after her father's death in 1919.

Today, the remaining eighteen buildings and forty-three acres survive as the West Overton Village and Museums. Visitors can go to the various buildings and learn about the town's history. The exhibits and staff help to provide a glimpse of what life was like in the early and mid-1800s for the people at West Overton. There are some visitors and staff, though, who claim to have caught glimpses of some things that they just can not explain. It seems that some residents of the historic village have never left.

Several of the buildings in the village are said to harbor ghosts. All were constructed between the years of 1826 and 1859 and were used during the village's peak years. Many people passed through and passed away in these structures. It is not surprising that rumors of hauntings have emerged from the venerable buildings. Many of the ghost stories were recorded by M.A. Mogus and Ed and Brendan Kelemen in their short book *Weird West Overton*.

It makes sense to start our look at these hauntings with the Overholt family home, now called the Homestead House. The three-story brick building was constructed in 1838 and housed various members of the family until it was purchased by Helen Frick in 1922. The first two floors are open to the public and have had only slight modifications over the years since the family moved out (one being the placement of a mural commemorating the French and Indian War in the parlor by Helen Frick). The third floor serves as the museum's archives. It was on the third floor that Clyde Overholt committed suicide in November of 1921. Forty-five-year-old Clyde shot himself three months after his mother's funeral. One unverified rumor claims that Clyde's brother Richard had emptied the house of its contents after their mother's death. Clyde was left with very little, and he could not deal with the emotional strain.

It is speculated that Clyde's ghost or the ghost of one of the other family members who died on the grounds over the years haunts the Homestead House. During off hours, staff members have allegedly heard footsteps

moving up and down the staircases. They sound real enough that sometimes the staff has to check to see if someone has wandered into the building. There have also been reports of a mysterious ringing sound, much like a phone, that does not seem to come from any of the staff phones. Full-body apparitions have also been sighted. A woman in white has appeared in certain rooms throughout the house. Though there have been several alleged encounters with this spectral lady, none have been verified and details remain vague. A shadowy figure has also been sighted moving though the offices on the third floor on at least one occasion. A staff member saw the strange shadow walk into an office and vanish. All the doors were locked, so it was impossible for anyone to have entered the building without a key.

The Homestead House is not the only haunted structure in the village. Other reports of strange occurrences have centered on what was the heart of the community, the distillery. Though the distilling equipment has been gone since Prohibition, the building is used for storage, maintenance and has a 150-seat auditorium called the Distillery Room. Whatever is haunting the distillery seems to be much more interactive than the ghosts of the Homestead House. According to Mogus and Kelemen, a museum director who was working upstairs sometime in the 1980s had a rather direct encounter. She was working in the storage area on the third floor when she felt the presence of someone nearby. "Get out!" she heard in a clear, stern voice. The director seemed to think that she had encountered the ghost of a former distillery manager.

A visitor was taking pictures of an exhibit on the first floor during the summer of 2005. She was standing alone, but a museum staff member was not far away. Suddenly it seemed that her camera was ripped from her hand and slammed on to the floor. Both the visitor and staff member were shocked. The camera was damaged, and no one could figure out what had just happened.

The home of Christian Overholt, which was built in 1840, was an L-shaped building with a store attached called the West Overton Emporium. Currently, half the building is being turned into a visitor's center and the other half is a quilting supply store called the Quilt Patch. Several workers in the building have seen a tall, shadowy figure in a hat in both the basement and on the top floor. A similar apparition was witnessed by several Civil War reenactors at an encampment held near the Big Brick Barn. At least two

of the men watched the shadow man pass their tents late one evening in July of 2006. One man emerged from his tent only to find that no one was there. Perhaps the mysterious figure is Christian or another member of the Overholt clan, still supervising their property from the grave.

From the 1870s to the 1920s, around one hundred coke ovens dotted the landscape at West Overton. Henry Clay Frick used the ovens to gain a foothold in the coke industry. A few of the dome-shaped brick structures still remain on the property. Mysterious red and yellow lights have reportedly been seen in and around the remaining ovens by people who live nearby. Are they the ghosts of the former workers? Are they just will-o-the-wisps or ghost lights emerging from nearby mines? No one really seems to know.

The Paranormal Society of Indiana University of Pennsylvania and WISP, a Westmorland ghost investigation team, combined to conduct an extensive investigation of the West Overton Museums in the fall of 2009. Members of both teams had personal experiences with what appear to be very interactive ghosts and captured several EVPs, or electronic voice phenomena. Two investigators witnessed a rocking chair rocking by itself on one of the upper floors of the distillery. An investigator discussing an oil painting in the Homestead House heard a disembodied voice whisper in her ear. Tape recorders caught at the same time a man's voice whispering "Thomas worker house." Several investigators in the upper level of the antique shop heard what sounded like a string of beads sliding off a desk and breaking apart when they hit the floor, but no beads were present. The lights in the old distillery, controlled by a single switch, were observed to turn off when no investigators were in that area of the building. EVPs included the voice of a woman in an old farmhouse apparently responding to an investigator's comment about the fireplace by repeatedly asking, "Aren't you cold? Aren't you cold?" Another EVP was caught as investigators entered the boyhood home of Henry Clay Frick, where an old man has been reported to be unfriendly to visitors—though no such old man works for the museum! In the EVP, a man's voice asks, "What are you doing in my house?" One dramatic EVP was both caught on tape by WISP investigators in the Homestead House and heard as it occurred: the loud and distinct sound of a shot ringing out from the second floor. Investigators immediately scoured the house and the grounds around it for any intruders but found none. Had they heard the residual sound of Clyde's suicide?

Many other unexplained occurrences have been reported by tour guides, staff and visitors over the years. What are they experiencing? Can it all be chalked up to overactive imaginations? It could be that such a historic and well-preserved place *seems* like it would be the perfect place for a haunting. Then again, if you believe in ghosts then it *is* the perfect place for a haunting. Are the ghost stories just another form of historical memory in a place that exists for that very purpose? You may just have to take a trip to the West Overton Museums and walk around the historic village to determine the truth for yourself.

THE HAUNTED HISTORY OF THE EVERGREEN HOTEL
ALLEGHENY COUNTY

As of this writing, the old Evergreen Hotel, which is situated at the intersection of Evergreen Road and Babcock Boulevard in Ross Township, is not much to look at. The once impressive Victorian-era hotel is now almost a ruin. Empty and condemned, it was damaged by broken pipes, a mold outbreak and a Jeep that crashed into it. It is expected to be demolished by its new owner, who purchased the building at auction. The hotel had been confiscated by the state attorney general when its previous owner was convicted on drug trafficking charges in 2006. It was the latest chapter in the old hotel's long and sometimes questionable history. That history includes a few ghosts.

The Evergreen Hotel was built in 1874, just down the hillside from the region's first planned suburb, Evergreen Hamlet. The hamlet was plotted out in 1851. It drew more people and business to Ross Township, which was mostly farmland. One of them was the hotel's original owner, Matthew Cridge. He lived in the hamlet and ran a short horse-drawn rail line that started on hotel property and ran down through Millvale (then called Bennett's Station). Even before the hotel and railway were constructed, the site was used for commerce. It was the location of the trading post of the settler Thomas Girty in the early 1800s.

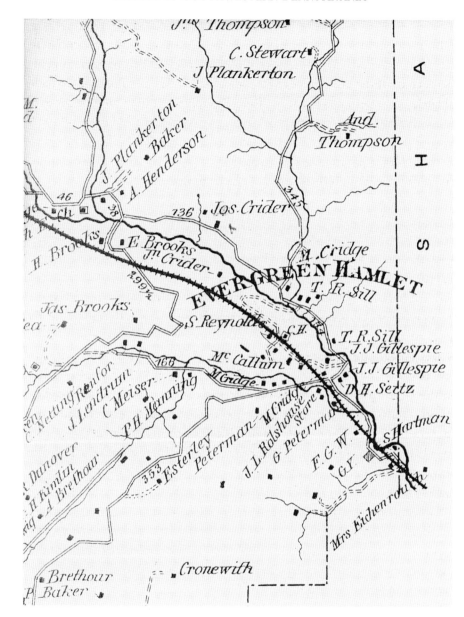

A map of Evergreen Hamlet from the 1876 *Centennial Atlas of Allegheny County*. Courtesy of the Library and Archives Division, Senator John Heinz Pittsburgh Regional History Center.

In its early years, the hotel was a club for gentlemen, and women had to enter through a side door if they were allowed in at all. This was common for men's clubs at the time. But even in those early years, the hotel would have clientele of a questionable nature. Ross Township historian John Schalcosky discovered articles linking the hotel with prostitution as early as the 1890s. A gang robbed the hotel in 1902 and blew the doors off its safe after poisoning the watchdog. They managed to escape with sixty-five dollars and a diamond stud worth two hundred dollars. They seemed to be familiar with the place. In 1905, the second owner, August Stitzer, struggled with county authorities to regain his liquor license after it was taken away because the bar harbored women from the red-light district. During the 1920s, the hotel functioned as a speak-easy. A secret room was hidden behind a trapdoor in the cabinets behind the bar and is still there today.

In the back of the hidden room is a stone tunnel that has been bricked up. It seems to run into and up the hillside. At least one house at the top of the hill has a matching bricked-up tunnel in its basement. The purpose and origin of this stone tunnel is not clear. It may have been associated with the speak-easy but could be older. For years, rumors circulated that the hotel was a stop on the Underground Railroad, possibly inspired by stories of the tunnel or tunnels. This cannot be true, however, because the building was constructed after the Civil War. If the Underground Railroad did use the area, they would have had to be stopping at Cridge's rail station, and this is unlikely. The true purpose of the tunnel, it seems, will remain a mystery. Given the history of the hotel, I would assume that whatever it was used for was probably not legal.

Things seemed to have been quieter at the hotel from the 1930s through the 1950s when the next generation of the Stitzer family, the Naumans, took over management. There was still the occasional rumor of prostitution. The owners also came under scrutiny for allegedly serving alcohol to some minors who were involved in a car accident.

By the late 1960s and early 1970s, the hotel's raucous reputation was returning. One of the more prominent members of the Pagans motorcycle gang, Stephen "Dirty" Kelly, was staying at the hotel frequently at that time. Another man who lived at the hotel did not like him and would frequently argue with Kelly. One evening, the two men fought while a John Wayne movie played on the television set. The other man pulled a .357 magnum and shot Kelly, killing him. The man then allegedly put the pistol on the bar

and said, "Tell the police I'll be upstairs." He casually walked up to his room and waited to be arrested.

In the late seventies and eighties, James Nauman revitalized the hotel and provided a venue for musical acts that ranged from local groups to Stevie Ray Vaughn and Billy Price. The hotel was always a crowded and popular spot during those years. There was also a successful high-end restaurant established on the first floor. Eventually, however, Nauman and the restaurant's head chef could no longer get along, and the restaurant closed. Nauman replaced the restaurant with a strip club named JezeBelles. It was not long before the old rumors of prostitution and illicit activities circulated again. In 2004, the hotel was raided for drugs and prostitution and Nauman was arrested on drug trafficking charges. The building was later confiscated by the state.

With such a checkered past, the Evergreen Hotel almost requires a haunting. One ghost that is said to inhabit the old building is that of James

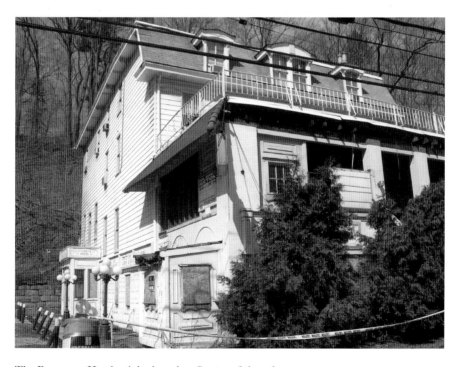

The Evergreen Hotel as it looks today. *Courtesy of the author.*

Nauman's great-aunt. While researching the hotel, John Schalcosky learned that an apparition of the aunt used to be seen on the upstairs floors, cleaning the rooms as she had decades before. The ghost was also seen in the hallways with a broom, sweeping dirt from the floor. She did not appear threatening in any way and seemed to go about her cleaning duties as if she were still alive.

Other rumors indicate that at least some people believe that "Dirty" Kelly's ghost haunts the bar and parts of the first floor. There have been reports of poltergeist-like activity in the area where he was killed, including flying dishes and glasses. Throughout the hotel, doors will apparently shut and lock themselves and lights turn on and off. Though much of this activity is attributed to Kelly's ghost, other rumors have claimed that one or more prostitutes mysteriously vanished from the hotel over the years. Though this has not been verified, it is sometimes implied that it is their spirits causing the disturbance.

The Evergreen Hotel has been many things over the years. It has also concealed many secrets. The ghosts of the hotel are just a few. Are the alleged hauntings a reminder of the hotel's past, or are they a reflection of a past that never really ended for a few of its residents? Whatever the case, it seems that the hotel's mysteries will remain just that.

SHADES OF DEATH ROAD
WASHINGTON COUNTY

Just to the north of Avella, Washington County, is a rural tree-lined road with an unusual name. No one (at least that I have encountered) seems to know its true origin. Shades of Death Road developed a scary reputation over the years. A road with such a name demands an associated ghost story. According to local legend, the road is haunted by at least one but possibly more ghosts.

In her book *Pittsburgh Ghosts: Steel City's Supernatural*, Heather Frazier writes about one legend that allegedly explains the name of the road and the origins of its ghosts. Sometime during the early settlement of the area there was an outbreak of malaria in the swamplike terrain near the road. After killing some of the settlers and sickening the others, the area was abandoned. The death of the settlers combined with the darkness caused by the trees that hung over the road led to the creation of the ominous name. The ghosts of the victims of the outbreak are allegedly felt and encountered today.

Another of the legends tells of the death of an escaped slave and purports to provide a different origin of the road's name. Some time just before the Civil War, a slave who was escaping to freedom in the north was caught just outside Avella. His captors allegedly lynched him on one of the long branches that stretched out over the road. It has been called Shades of Death Road ever since. The ghost of the slave haunts the road where he died. The

details of the story are vague, probably because it is not likely to be true. One reason is that substantial rewards were offered for escaped slaves, and it is much more likely that a fugitive slave who was recaptured would be handed over for payment. A modern variation of the story has circulated as well. It tells of a black man who was lynched by the Ku Klux Klan on the road, sometime during the mid-twentieth century. Again details are vague, but his ghost is still said to haunt the road at night. The Klan element is fairly common in many haunted road stories. A similar tale is told about Blue Mist Road in Allegheny County. (The story of Blue Mist Road is discussed in my book *Legends and Lore of Western Pennsylvania*.) Still another version of the hanging-man story is told about a young man who had lost his job and girlfriend-fiancée. He was so distraught that he went out to the isolated road and hanged himself on one of the tree branches. His decaying body was not discovered for days. If you get out of your car and walk around, you can hear the hanged man walking and breathing nearby, but you will not necessarily see him.

Another ghost that can supposedly be encountered on Shades of Death Road is that of a young man who died in a tragic car accident. The legend says that one night, a few decades ago, the young man somehow lost control of his car while traveling on the road. In some versions, it was the ghost of the lynched man that appeared to him and caused him to swerve. He went off the side of the road and into a tree. The man died at the scene, but his spirit still lingers, angry or in denial about his untimely death. There have also been some reports of visitors being chased off by other cars or mysterious vehicles. Whether this is true or not, it has added to the legend of the road. It may also be tied to vague rumors of satanic cult activity on the road. Once again, like the other legends, these probably emerged during the Satanic Panic of the 1980s.

Though there does not seem to be much of a ritualistic element aside from actually driving down the road and possibly getting out of your car, the rest of this ghost story seems to fit the urban legend–legend trip tradition that was mentioned in the introduction. It has vaguely rumored deaths, a scary name and is isolated but also easily accessible by car. Driving down the road at night waiting to be frightened by the ghost of a hanged man or chased off by mysterious vehicles could be interpreted as a test of bravery (or an attempt to get your girlfriend to move a little bit closer).

THE GHOST OF FRIENDSHIP HILL

FAYETTE COUNTY

Friendship Hill is a National Historic Site located just outside Point Marion in Fayette County. It was the home of Albert Gallatin, who served as secretary of the treasury under Presidents Thomas Jefferson and James Madison. The original section of the brick house was built in 1789 for the twenty-eight-year-old Gallatin and his new wife, Sophie Allegre. Five more sections would eventually be added to the original federalist-style house by Gallatin and later owners, including a stone kitchen in 1823. The last addition was the servants' quarters in 1903. The historic home overlooks the Monongahela River.

Albert Gallatin had a remarkable career in early American politics. He had been born in Geneva, Switzerland, on January 29, 1761. Gallatin came to America in the early 1780s and briefly taught French at Harvard University. He managed to save enough of his salary to purchase the 370 acres that became Friendship Hill. For the rest of his life, Gallatin would be involved in an amazing array of activities. He was a senator, congressman and diplomat. As a politician, he was a member of the Democratic-Republicans and an ally of Jefferson. He served as house majority leader and opposed the programs of Alexander Hamilton. During the War of 1812, Gallatin helped broker the Treaty of Ghent, which officially brought hostilities to a close. After the war, he spent seven years in France as a diplomat.

Gallatin was also very active in western Pennsylvania. He loved his property and enjoyed spending time at Friendship Hill. He was one of the pioneers of the early glass industry in the region and ran a glass business until 1821. During the Whiskey Rebellion in 1794, Gallatin attempted to chart a moderate course of resistance instead of violently opposing the new whiskey tax. After returning from France he lived at Friendship Hill until 1826. After that, he spent two years as a diplomat in Britain and then moved to New York City and became a bank president. He died in 1849.

The ghost that haunts Friendship Hill is not the ghost of Albert Gallatin, however. It is his young wife, Sophie, who allegedly still walks the halls of the historic home. According to the story, the young Sophie was not fond of living so far out on the frontier but agreed to move there because she was deeply in love with Albert. They had eloped because her mother did not approve of Gallatin. The home was not even complete when they moved in, and Albert frequently had to make trips east to Philadelphia and other locations for political meetings. Unfortunately for the couple, they would not have much time together. Less than a year after they had moved into Friendship Hill, Sophie was dead. Some versions of the story said that she died of a broken heart or from loneliness, but in actuality she may have died from a miscarriage.

Albert was deeply distraught. He had his young bride buried on the hilltop overlooking the river. Gallatin eventually remarried in 1793. His new wife, Hannah Nicholson, did not particularly like living at Friendship Hill either.

Supposedly a later owner of the property, though it is not clear who, had Sophie reinterred closer to the home. Her grave is now surrounded by a simple stone wall. While this story may be true, and the wall certainly exists, there is no definitive proof that the body was moved. It has been implied that some of the bones were lost when they were relocated. This is offered as one of the possible explanations for the haunting. Later owners of Friendship Hill include Congressman John Littleton Dawson and coal baron J.V. Thompson. Dawson spent his retirement in the home and actually died there when he tripped down a stairwell in 1870.

Reports of Sophie's ghost have circulated for many years. Members of the Thompson family reported hearing footsteps upstairs and in the attic. They also would occasionally feel columns of cold air pass by them, especially in Sophie's old room. The family dog would sometimes bark at someone

The interior of Friendship Hill in 1933. *Courtesy of the Library and Archives Division, Senator John Heinz Pittsburgh Regional History Center.*

who was not there. Today, staff members and visitors still hear someone walking upstairs in areas where visitors are not allowed. The ghost never seemed threatening to those who have heard or felt it. Maybe Sophie is simply spending time in the home that she never really had a chance to live in. Maybe the ghost exists only in the mind of the believer. Either way, the legend of Sophie's ghost does help us to remember a young woman whose short life would otherwise be lost as a footnote to the grand career of Albert Gallatin.

THE DEACON IS WATCHING
ALLEGHENY COUNTY

If there were an award for the local museum with the most unusual name, that award would go to the Depreciation Lands Museum on Route 8 in Allison Park, Allegheny County. It is a living history museum that educates visitors about the lives of the early settlers and inhabitants of the Depreciation Lands. If the stories that are told about the museum are true, then at least one of those settlers has decided to stick around.

Such a unique name requires some explanation. The Depreciation Lands once encompassed the entire North Hills area of Allegheny County as well as parts of Armstrong, Beaver, Butler and Lawrence Counties. The strange name was an indirect result of the American Revolution. After the war, veterans found that the new continental currency that they had been paid with depreciated rapidly and soon became nearly worthless. The new United States barely had the resources to back its own money, which was not yet accepted as a legitimate form of payment by everyone. The fledgling nation was not prepared to deal with a revolt by angry veterans whose pay had no value. Land, however, always retained value, so Benjamin Franklin and others suggested compensating the veterans with property. One thing that the United States had in abundance was land. The new government and the state of Pennsylvania surveyed the almost vacant frontier north and west of the Ohio and Allegheny Rivers. Over 700,000 acres were divided

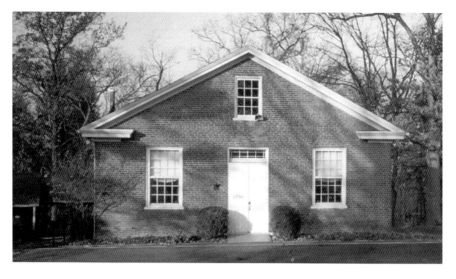

The Depreciation Lands Museum's main building, 1999. It was constructed in 1843 and was formerly home to the Pine Creek Covenanter Church. *Courtesy of the author.*

into five districts consisting of many smaller plots. The government also saw a benefit in placing experienced and well-trained veterans on the frontier because they would be better suited to repel raids from hostile Indians. The land had been hunting grounds for some of the tribes. Compensation was paid to those Indians who agreed to surrender the land, but to those who did not, it was a hostile occupation. Not all veterans were willing to relocate to the isolated frontier, however, and many of the land certificates that they were issued were sold off to third parties who eventually came to settle.

The museum itself is made up of several buildings and a graveyard. The oldest structure on the property is the Armstrong log cabin that dates to 1803. It was moved to the site in the end of 1973 (the same year that the museum was founded) from its original location nearby. Each log was carefully moved and reconstructed exactly as it had been at its original site. The main museum building was built in 1843, and once was home to the Pine Creek Covenanter Church. The building was no longer used as a church by the 1960s, and it was eventually acquired by Hampton Township to serve as the heart of the museum. The grounds also include a replica 1880s schoolhouse, a fully functional blacksmith shop and a wagon house that houses an authentic Conestoga wagon, as well as antique agricultural

The Armstrong log cabin was originally constructed in 1803 but was moved to the museum property in 1973. *Courtesy of the author.*

tools and a plank from the old Butler Plank Road. The graveyard in front of the buildings contains some burials from the early 1800s. Most of those interred there were members of the congregation.

As far as ghosts go, the one who supposedly haunts the Depreciation Lands Museum is unique. Though the true origin of the ghost is unknown, the staff of the museum affectionately named him the Deacon because of his activity in the old church. The Deacon seems to be much more helpful than other ghosts that we have discussed. The ghost first manifested itself during the renovation work done on the buildings in the midseventies. The encounters from that time have been discussed in the museum's newsletter and other publications. Hauntings are often believed to be linked to renovations in old buildings, whether there are actual connections or not. One theory is that the physical changes somehow disturb or activate ghosts that are tied to a specific location. If a link does exist, there are also other ways to look at it. Renovations can cause new noises in old buildings. Creaks, groans and rattling that did not exist before can appear with the physical changes. Also, this type of work is often carried out by people unfamiliar with the old structures who are there just to do a specific job. Sometimes imaginations can be stirred by one's surroundings. For some these mysterious noises may seem ghostlike.

The Deacon, however, was much more interactive than some creaking floorboard or groaning pipe. One encounter with the ghost occurred when a boy was helping paint a door frame near the stairwell. He was up on the top of a ladder when it began to tip. Other workers were too far across the

room to catch the ladder. Just as it passed the tipping point and began to fall, it mysteriously stopped and then slowly returned to an upright position. The other workers all witnessed this occurrence. If the ladder had not stopped, the boy would have plunged all the way down into the basement.

Another visit from the Deacon was reported during the renovation. It involved a woman who had been working in the old church all day, replacing broken windows. The last window did not fit properly, and the tired and frustrated woman was having difficulty trying to shave the wood on the window frame to make it fit. Though she had been alone for a while, she continued to sense that someone was in the room with her. At one point she caught a glimpse of a man in her peripheral vision, but when she turned there was no one there. A few minutes later, she saw tall, old-fashioned black boots and dark homemade pants out of the corner of her eye. The window still would not fit, and the woman finally blurted out "Well don't just stand there—the least you could do is help." The knife that she was using (that was still in her hand) suddenly slipped down the inside of the window frame, trimming the wood to a perfect fit for the glass.

One young woman, who was helping with the restoration, looked up one day to see an older man in a long black coat looking in the window. She looked away for a moment, and when she turned her head back he was gone. Something did not seem right, but the man did not feel threatening. Later that day, the same young woman sat down outside in the graveyard near some bushes to take a break. After a few moments, she felt a hand on her shoulder. She pulled her arm away and looked around. No one was there. When she turned back she saw that a snake had slithered out of the bushes, exactly where her hand had just been.

The Deacon seemed to be quiet for a while, but some believe that he made his presence known again in the early 1990s. An incident occurred during a Girl Scout sleepover in 1993 in the annex building, which is next to the church. Years earlier, during the renovation, the tile ceiling was covered with a drop ceiling for aesthetic reasons. There had never been any issues with the ceiling since it was installed. The Scouts were asleep, sprawled all over the floor in their sleeping bags when it happened. Some of the original ceiling tiles broke loose, knocking down the drop ceiling and even light fixtures as they fell. The adults were awakened by the sound of the materials crashing to the floor. Fearing injuries, they were soon surprised to see that none of the tiles, glass

The graveyard at the Depreciation Lands Museum, 1999. The Armstrong log cabin and the replica one-room schoolhouse are visible in the background. *Courtesy of the author.*

or metal had landed on the children. Most of them were still sleeping. Given the amount of material that fell and the position of the Scouts, it seemed that at least some of them should have been hit by falling debris. Was it just luck? Or were the children under the protection of the Deacon?

On another occasion, a different troop of Girl Scouts was spending an evening in the Armstrong cabin telling stories. They kept hearing strange tapping sounds. The Scout leaders looked everywhere for the source of the noise but could not find it. The noise continued intermittently until they left. Other staff members have reported hearing mumbling in the basement of the church and walking through sudden cold spots in the building, even on warm days.

Some of these happenings could possibly be explained by coincidence, tiredness and luck. The Deacon may have been created by the historically inspired imagination of dedicated volunteers and workers who labored to restore the site and open the museum. Then again, gravity does not reverse itself. A ladder pushed past the tipping point should fall. Perhaps the Deacon emerged from his grave to help restore and protect his beloved church. If you want to learn the truth for yourself, pay a visit to the Depreciation Lands Museum. And, who knows, maybe the Deacon will find you.

CRIES AT THE BLACK CROSS
BUTLER COUNTY

At the end of the First World War, a deadly plague swept the world. The 1918 influenza outbreak, also known as the Spanish flu, ultimately caused many more deaths than the war itself. At least 50 million people were killed by the flu worldwide, and the number may have been as high as 100 million. Unlike other strains of influenza that tend to be fatal for those already sick, the old or the very young, the Spanish flu killed young adults who were otherwise healthy. It is believed that the cramped conditions and crowded hospitals that existed in Europe during the war allowed an already potent strain of the flu to mutate and became deadlier. Travel after the war spread the disease to the Americas and around the world. Soldiers returned home and carried the virus with them. Some regions had a mortality rate as high as 20 percent. In the United States, the flu may have killed as many as 675,000 people.

The Spanish flu reached western Pennsylvania in September of 1918. There were a few cases at first, but by October it was everywhere. Some communities were unable to cope with the large numbers of casualties. Sometimes dozens would die in a few days. Fearing the further spread of disease, authorities wanted the bodies buried quickly. It was not uncommon for mass graves to be used to cope with the problem.

Such was the case in West Winfield Township in Butler County. The township, which is located near the border with Armstrong County, was home to several small mining and manufacturing companies. Many of the people who lived in the area were immigrants who had recently come to find work. When the flu swept the township and people began dying, there was often no family to claim the bodies. As a result, the community and business owners decided to bury the bodies in mass graves. Each grave at the makeshift cemetery officially held anywhere from one to five bodies. Several of the workers who hauled the bodies to the site and worked at the graves later reported as many as twenty bodies in each grave. At least three hundred people died of the Spanish flu in this part of Butler County, but it is not clear how many were buried in the mass graves.

A local priest from Coylesville felt that the immigrants deserved a proper burial service. Father O'Callahan had a large wooden cross constructed out of railroad ties and saw that it was placed at the grave site. He also conducted a Catholic burial service at the grave for the hastily buried immigrants. The cross that he had constructed, the Black Cross, marked the site for decades. The unusual grave became the center of many legends.

For years it has been reported that strange phenomena occur at the graves. One account insists that if you go to the burial site during a full moon, you will hear babies crying. Around October and November, the months when so many victims died, supernatural activity at the burial site increases. Strong winds seemingly blow out of nowhere. Some visitors have reported that the whole area will become extremely cold for several minutes. The most disturbing happening occurs when it is quiet. The voices of the buried immigrants can supposedly be heard talking in low muffled tones. The sound can be heard coming right out of the ground. Even the trees that surround the mass graves are reported to take on strange and menacing shapes late at night.

Eventually bad weather and vandalism destroyed the original wooden cross. In recent years the local community raised money to place a new burial marker next to the site of the old one. It was put in place in 2002. The graves are located near the intersection of Cornetti and Sasse Roads on property that belongs to the Armstrong Cement and Supply Company. A new historical marker was also placed at the grave site by the Saxonburg District Woman's Club to tell the story of those buried there.

It reads:

Influenza Epidemic Victims
Here are buried an unknown number of local victims of the worldwide influenza epidemic of 1918–1919—one of history's worst epidemics in terms of deaths. In Butler County, the worst period was early October to early November 1918, with some 260 deaths in the county seat alone. Immigrant workers in the limestone and other industries are buried in this cemetery, with one to five bodies in each grave. A large wooden cross long marked the site.

The ghost story associated with the Black Cross appeared to have passed its zenith years ago when the original cross had disappeared. The legend did not die, however, and recent events have brought new life to this ghost story. The combination of the new grave markers and media-driven scares of new epidemics from bird flu and swine flu have reinvigorated this legend. The current flu scares have been accompanied by numerous comparisons to the 1918 epidemic as a worst-case scenario. This haunting resonates with young people today because it links the supernatural (and elements of the legend-trip experience) with a frightening contemporary threat. Most of the people buried in the grave site were young themselves. It is both a lesson in history and a reminder that epidemics are not just a thing of the past but something that can reoccur in the future. Even the young cannot escape death if it is their time.

GHOSTS IN THE CATHEDRAL OF LEARNING

ALLEGHENY COUNTY

The late gothic revival-style skyscraper that we know as the Cathedral of Learning dominates the landscape and architecture of Pittsburgh's Oakland neighborhood. The cathedral is the heart of the University of Pittsburgh and is the second-tallest academic building in the world. Though the building was officially dedicated in 1937, its roots date back to the early twenties. The university's tenth chancellor, John Bowman, envisioned a grand structure at the heart of the campus that would symbolize the city of Pittsburgh and the university. A tall building could also accommodate the growing number of students that were attending the university. After the prominent Mellon family purchased the land on which the cathedral would be built, Bowman hired architect Charles Klauder to design the building. The design took two years, and after some clashes with the board of directors over the building's height, construction began in 1926. When it was completed, the Cathedral of Learning stood over 530 feet tall and had 42 stories and more than 2,000 rooms. Though it has a steel frame, the outside of the building was faced with Indiana limestone to create its gothic style.

The interior of the building has many unique architectural features and special rooms. It apparently also has ghosts. Strange happenings have been reported in some of the most unique places in the cathedral. One of the

The Cathedral of Learning under construction. *Courtesy of the Library and Archives Division, Senator John Heinz Pittsburgh Regional History Center.*

most popular ghost stories centers around one of the building's Nationality Rooms. The Nationality Rooms were also the idea of John Bowman and Ruth Crawford Mitchell. They wanted each room to be adopted and furnished by a different ethnic group, highlighting specific periods (pre-

1787), architecture and cultural achievements. There are twenty-seven rooms in total, depicting everything from African culture to ancient Greece to Japanese culture. The majority of the rooms are designed to be used (and are used) as functioning classrooms.

One of the two rooms that do not function as a classroom, but rather as an exhibit, is the Early American Room located on the third floor. Room 328 depicts life in New England in the 1650s, complete with a fireplace made of two-hundred-year-old bricks and accompanying tools like an iron kettle, waffle iron, ladles and bread shovel. The room has other artifacts from colonial America such as antique coins and a spinning wheel. Reproductions, such as the tin light fixtures and wooden table and benches are as authentic as possible. Inside the closet there is even a secret door. It opens to a set of stairs that lead up to a small bedroom. A rope bed and a small cradle furnish the bedroom. On the bed is an antique wedding quilt from 1878. It belonged to Martha Jane Poe, a relative of Edgar Allan Poe and grandmother of the longtime director of the Nationality Rooms, E. Maxine Bruhns. Her picture sits in a frame beside the bed. It is Martha's ghost that is said to linger in the room.

The first encounters with the ghost started in 1979, shortly after the Bruhnses donated their grandmother's belongings. One of the custodians was in the bedroom cleaning when he noticed that the quilt was turned down. Usually the artifacts were not touched and the room was always locked, so he found it to be a little unusual. He remade the bed and continued cleaning. A few minutes later he heard a soft noise. He looked back at the bed and found that the quilt was turned down again, and this time, there was an imprint on the pillow in the shape of a head. Recently it was reported that a member of the cleaning staff was going up the stairs to the bedroom and saw a shadow step away from the bed and disappear in front of him.

Over the years, tour groups have also experienced strange phenomena in the room. One group arrived in the bedroom to find the cradle rocking. No one had been in the room for hours. Another group arrived in the main room with the fireplace and smelled freshly baked bread. Others have reported seeing candles suddenly light and then go out by themselves. According to Bruhns, she became convinced of the haunting after some renovation work was done in the room. To protect her grandmother's picture, she carefully wrapped and packed it into the dresser drawer beside her grandfather's Bible. When the work was completed, she unwrapped the frame to find that

the glass had cracked in two places. The workers insisted that they had not caused any damage to the frame. Bruhns decided that it was the ghost of Martha who had caused the damage. Perhaps she was unhappy with the disturbance in the room.

Another unique room that is rumored to harbor a ghost is the Croghan-Schenley Ballroom. The ballroom, which is actually two adjoining rooms, is the last remnant of the once luxurious Greek-revival style Croghan picnic house. The house was built in the 1830s and was located in Stanton Heights. The rooms were donated to the university in 1955 and, with the exception of having to lower the ceiling a few inches, the rooms were reconstructed exactly as they originally were on the first floor of the cathedral. The story of the ballroom's creation is also tied to the ghost who allegedly inhabits them.

The house was originally the childhood home of Mary Croghan, daughter of Colonel William Croghan Jr. The colonel had a ballroom constructed in anticipation of his daughter's coming-out party, like all the

William Croghan as a young man. *Courtesy of the Library and Archives Division, Senator John Heinz Pittsburgh Regional History Center.*

other young debutantes would have. Coming-out parties were often held instead of debutante balls in the northern states. Croghan even had an expensive chandelier installed so that the family could impress their friends and neighbors. Before the party, when Mary was around the age of thirteen, he sent her to a young ladies finishing school on Long Island for a brief stay. He soon regretted his decision.

At the boarding school, Mary met British captain William Schenley, brother-in-law of the school's headmistress. Schenley was forty-three years old and a widower, but Mary fell in love with him. They had eloped and were married by the time she was fifteen. Croghan was furious, and he came close to disowning his daughter. When Mary had children, the colonel reconciled with her, but she would only visit Pittsburgh for brief periods of time. She later inherited large amounts of land in Oakland (including what would become Schenley Park and the property on which the cathedral was built) and donated a large portion of it to the city of Pittsburgh.

When the ballroom was donated, it seems that a ghost came with it. It is believed by some that the spirit of Mary Schenley still visits the rooms that she never had the opportunity to use. Like the Nationality Rooms, the Croghan-Schenley Ballroom is locked when not in use. That has not prevented the staff from occasionally finding the furniture rearranged when they open the doors. The other indication of Mary's presence is the chandelier. When it moves on its own, some believe that Mary has entered the room.

Martha and Mary are not the only ghosts rumored to be in the building. Unfortunately, because of the Cathedral of Learning's height, it has been the site of several suicides and attempted suicides. These deaths have spawned rumors of ghosts on some of the upper floors. Though I do not wish to dwell on the details of these unfortunate deaths, one particular story was widely covered in the press. The dramatic incident occurred in August of 1959 when a professor of philosophy threw himself out of his office window on the thirteenth floor. The forty-seven-year-old man had been spending time at the Western Psychiatric Institute because he had suffered brain damage of an undetermined origin. The damage had been causing him to act erratically. He had been improving in recent weeks, so he was released into his wife's custody at 3:00 p.m. on August 19. The professor asked his wife to stop at his office so that he could pick up some books. He went inside, opened the window and attempted to jump out. His wife grabbed his leg and screamed for help.

The Cathedral of Learning towering over Oakland, 1999. *Courtesy of the author.*

Another man rushed in and grabbed the other leg, but the professor was able to kick free. He fell to the fourth-floor parapet and was killed instantly.

The details of these hauntings are vague. Sometimes ghosts are reported wandering the halls of the floor that they jumped from. One "friend of a friend" report has even placed them on the outside of the building, on ledges or in the windows. Most likely these vague stories serve merely as a memory of these tragic and shocking deaths rather than a record of any actual encounter.

The Cathedral of Learning has a rich and unique history. Are its ghost stories merely a popular remembrance of that history? Are they just college legends? Or are ghosts really roaming the historic rooms and storied halls, tied to the objects that they contain and the events that they have witnessed? Maybe if spirits were to feel at home anywhere, it would be in Pittsburgh's imposing gothic tower.

THE GATES OF HELL
FAYETTE COUNTY

Any of you who have ever suspected that the Gates of Hell were located in western Pennsylvania may be right, at least according to one local legend. The ominous-sounding gateway is located along Tent Church Road near Uniontown, Fayette County. Actually the name is a bit of an overstatement. The Gates of Hell are really a metal farm gate that is painted blue. The blue gate is a replacement for a much scarier-looking wrought-iron gate that blocked the old, isolated driveway decades before. Gates of Hell legends are fairly common around the country. Several exist in this state and in surrounding ones. They are almost always destinations for young people who venture out on a legend trip. The Gates of Hell on Tent Church Road are no exception.

The story behind this Gates of Hell legend involves a murder–suicide. Decades ago there was once a small farmhouse and a barn at the other end of the now overgrown dirt driveway. At some point the house burned to the ground. Supposedly, the man who lived there had entered into a heated argument with his wife late one night. In a fit of rage he killed her. He then proceeded to light his house on fire before killing himself. The property has been haunted ever since that tragic night. In the years that have passed since then, numerous young people have visited the gates and have had strange experiences and feelings of uneasiness and dread. Early on, visitors would

travel up to the foundation of the house and ruins of the barn. When no trespassing signs appeared and the blue gate went up, most of the experiences shifted to the gates themselves.

The legend said that if you walked through the old iron gates at midnight, you would never be seen again. This seems to be a common element in many of the similar legends around the country. A variety of other supernatural phenomena have manifested themselves on the property as well—if you believe the stories. Crying and talking have been heard near the foundation and the gate. Sometimes a creepy, almost maniacal laughter echoes down the old driveway. Several visitors reported strange blue lights moving around the property. The lights even followed some of them to the gate and beyond. Mysterious and frightening growling sounds have been heard around the gate. There are a handful of sightings of a menacing black dog that will seemingly appear out of nowhere to chase off trespassers and then disappear. It will even approach any cars that are parked near the gate. This is similar to the black dog legend associated with the Quaker church discussed earlier. Given their proximity to each other, one wonders if the black dog element was borrowed from the Quaker church. A dark shadowy figure allegedly wanders near the gate at night. On at least one occasion the shadow man was reported to have red eyes. It has been suggested that the figure is the ghost of the murderer or perhaps even something demonic.

In recent years the area around Tent Church Road has seen more development. New houses have been constructed near the once remote Gates of Hell. Perhaps this will lessen the appeal of the site to legend trippers in years to come. Please remember that the entire area is made up of private property so do not trespass. If you do, you may discover that angry neighbors can be more frightening than the Gates of Hell.

THE PHANTOMS OF COVERT'S CROSSING BRIDGE

LAWRENCE COUNTY

The New Castle area has its own haunted bridge. Covert's Crossing Bridge connects Union and North Beaver Townships in Lawrence County. It has also been the source of many ghost stories. The bridge that currently bears the name Covert's Crossing was constructed in 2003 just to the west of the original structure. The first bridge was built in 1887, stretching across the Mahoning River. It was named after a prominent physician from New Castle named John W. Covert who owned the surrounding land. The Morse Bridge Company from Youngstown, Ohio, erected the structure because the local population found it difficult to get to New Castle when the river was high.

Much like Summit Cut Bridge in Beaver County, the original bridge had a sharp and dangerous curve. Over the years it has been the site of several actual and rumored accidents. According to legend a carriage went off the bridge around the turn of the century. It happened around Halloween and the young couple inside was killed. In some versions they were decapitated. Their ghosts are said to be visible on the riverbank below around Halloween, wandering in confusion near the site of their accident. Another crash was reported there in the 1940s. A young woman went off the bridge around midnight on the way home from her high school prom and was killed. If you go to the bridge around midnight, you can see her walking there in her white

Covert's Crossing Bridge in Lawrence County, 2009. *Courtesy of Michael Hassett.*

gown. If you park your car in the middle of the bridge and turn off your headlights you will be able to see her. Several other documented accidents occurred on the bridge in more recent decades. One involved the death of a young woman who was not wearing her seatbelt and was thrown through a car windshield. The design of the new bridge has eliminated some of the dangerous conditions that plagued the previous structure, so hopefully there will be no more accidents.

Like other stories in this book, rumors of cult activity have circulated about the bridge since the 1980s. Again they are vague, but the cult supposedly burned down the original bridge in some kind of ceremony. This is untrue, but it adds another layer of mystery to the legend when it is told.

Phantom Indians and Indian encampments have also been reported to appear near the bridge and along the riverbank. They do not seem to interact with visitors, but rather replay events of the past. They materialize only briefly, and sometimes their campfires can be seen from a distance. This legend probably grew out of the construction of the new bridge. When

archaeologists surveyed the new site, they found evidence of Indian habitation from around one thousand years ago. Their excavation temporarily delayed construction as they hurried to recover artifacts and evidence that would otherwise be lost. Though Indians were known to have inhabited the area before the discovery, the archaeological work interjected the Indian element into the lore of the bridge.

The ghosts of Covert's Crossing Bridge seem to serve simultaneously as community memory and legend trip. The Indian ghosts are a reminder of the area's original inhabitants, and are almost a simple, noninteractive history lesson. They replay the same scenes because there is no context for them to easily interact with your average modern person. As Renee Bergland argues in *The National Uncanny: Indian Ghosts and American Subjects*, tales of Indian ghosts represent both the triumphs and failures of American nationalism. As the Indians lost their land, the United States grew and prospered. In this sense Indian ghosts can represent a strange mixture of both guilt and pride. The young woman in the white gown and the young couple were a reminder of the dangers of the old bridge and the deadly accidents that happened there. On the new bridge, which is less dangerous, the ghost story became a legend trip. It offers another opportunity to interact with the supernatural.

SOMETHING CAME WITH THE BUILDING
ALLEGHENY COUNTY

When Duquesne University purchased the former Fisher Scientific building on Forbes Avenue in the mid-1990s, it seems that they got a little more than they paid for. Apparently a resident ghost came with the building free of charge. For a few years, employees in the Fisher Café (which is no longer in operation) had some increasingly disturbing encounters with an unknown entity.

The Fisher Scientific Company had moved into the building that bears its name almost one hundred years before the incidents. The structure is actually five buildings that are attached through the interiors and have a common façade. Chester Fisher, the company's founder, and his descendents manufactured equipment such as flasks, test tubes, barometers and thermometers. In later years the building would include a small museum dedicated to Louis Pasteur. The museum stayed in the building for a few years after the university purchased it (though it remained the property of Fisher Scientific), and it was located near the Fisher Café. The university renovated the rest of the building so that it could be utilized for classroom space and to house various administrative departments. It was named Fisher Hall.

During the first few years of operation, a variety of strange occurrences were reported around the café and museum by both staff and managers.

Fisher Hall at Duquesne University, 1998. *Courtesy of the University Archives and Special Collections, Duquesne University.*

Many experienced a sense of uneasiness or the feeling of not being alone. One manager began hearing the heavy kitchen doors open and close when she knew that she was alone. Strange gusts of wind would mysteriously blow paper around her desk in her small office that had no windows. As time went on, the occurrences seemed to intensify. By 1998, the manager and another employee heard screams from the hallway near the museum. When they tried to find the source, they discovered that the hallway was empty.

The most direct encounter happened in September of 1999. The same manager was walking into her office when she sensed the presence again. As she reached for the light switch, she felt a cold breath on her hand. Then a voice said, "Leave it off." She ran out of the office of course. After the frightening encounter, the staff of the café asked if one of the Spiritan priests could bless the café. Less than a week after the incident, several priests came down to Fisher Hall and blessed both the café and the employees. After the blessing, the ghostly encounters stopped. Eventually the Fisher Café closed, and no strange happenings have been reported since.

The story of the ghost of Fisher Hall differs from most other college legends. First of all, it did not originate among the students and it never really circulated widely among them. It seems to have survived longer on the Internet than on campus. The story is not a cautionary tale in disguise and does not seem to have a hidden message. As for the possibility of representing some type of community memory at the university, the building had been recently purchased and the details of its history were not widely known among the staff other than basic information. This ghost story seemed to convey no form of popular history or commemoration. No identity has ever really been assigned to the ghost, though a few thought that it might be a member of the Fisher family. The fact that this story does not seem to fit in the usual mold gives it a level of authenticity. As always, there is the possibility that somehow the multiple witnesses convinced themselves that they were experiencing a haunting when none existed, but they all genuinely believed that their encounters were real. Since the haunting ceased with the blessing, we will never really know.

GHOSTS AT THE KKK HOUSE
LAWRENCE COUNTY

There is another well-known legend-trip destination in Lawrence County, popularly known as the KKK house. The old and vacant house is located on Shaw Road near Harlansburg. The story has been passed around at Laurel High School for years and has gradually spread around the county. Like the other legend trips, teenagers frequently bring their friends and girlfriends to the house on late-night expeditions. According to the legend, the house was a meeting place for the Ku Klux Klan decades ago. They gathered in the nearby fields for rallies and even carried out lynchings on the hanging tree, which is located near the road several hundred yards from the house. The ominous-looking tree still stands alone in the field.

When legend trippers visit the house today it does not look as scary or run-down as one would imagine. That is because the legend also claims that the house does not age. Supposedly abandoned for years, the house seems well-kept. It is implied that some kind of evil supernatural force preserves the structure. Allegedly, if you visit the house late at night, you will see faces in the windows staring back at you. The ghosts of Klansmen supposedly walk around in the fields nearby. Of course no one ever gets close enough to confirm the existence of these ghosts.

There is no actual verification of any part of this legend or its background. Like similar tales, the quasi-isolated nature of the house and rumor and

The hanging tree located near the KKK House in Lawrence County. *Courtesy of Angela Wells.*

speculation appear to have spawned it. The house does not seem to age because someone owns it and maintains it, and I am sure that they do not appreciate trespassers. Many legend-trip sites have alleged Klan or cult activity. It is a common feature in this type of folklore throughout the Midwest and northeastern United States, where the second Ku Klux Klan had emerged decades before. The Klan rumors appear to mainly be found in suburban and rural areas where people tend to believe that the modern Klan is located, as opposed to some cult legends that thrived in both urban and rural areas. Some places have reputations for harboring both the Klan and cults, like Shades of Death Road and Blue Mist Road. Many of these Klan legends seemed to have emerged in the late 1960s and 1970s, perhaps as a folkloric response to the lingering racial tensions of the civil rights era. Almost all of them seem to contain some type of hanging tree. Since lynching is the act most associated with the Klan in modern popular culture (besides cross burning), that element of the story makes perfect sense. As with most of these stories, when one takes a closer look it, it is clear that there was not a string of rather obvious murders at the site. Of course, for those who believe the legend, it is only an indication that it was quietly covered up by well-connected members of the secretive group.

WHO WALKS AT THE WEITZEL HOUSE?

ALLEGHENY COUNTY

Tucked away along a wooded residential road in Ross Township, Allegheny County, is a very old haunted house. The property was owned by some of the township's early residents, the Weitzel family. The Weitzel house sits back off of Evergreen Road, shielded by rows of trees. It seems a little isolated despite the fact that apartment buildings now stand behind and beside what is left of the original lot. Enough strange events have occurred there over the years for the house to be featured on a 2007 episode of the television show *Paranormal State*.

John Schalcosky, a Ross Township historian, researched the history of the Weitzel (sometimes spelled Whitesell) house and family. Lieutenant Jacob Weitzel, the patriarch of the family, was a Revolutionary War veteran who was given two hundred acres in the Depreciation Lands in 1790. He waited fifteen years to move his family to his new property, and they stayed in a log cabin constructed on the site of the present house in 1805. Weitzel's plan was to set up a large farm. He only lasted four years on the frontier though, and a week before his death in July of 1809 he wrote his will. In the document he instructed his family to take down the cabin and build a much larger farmhouse on the foundation. The house that they constructed is the one that sits on the property today.

CANDLESS TOWNSHIP

A warrantee atlas map showing the property of Jacob Weitzel. *Courtesy of John Schalcosky.*

Officially the house was built in 1820, but Schalcosky discovered evidence that indicates that the house was built by 1814. This earlier date makes more sense. Most settlers abandoned cabins for larger houses as soon as it was possible. It was Jacob's oldest son, Jacob Weitzel Jr. and his wife, Jane Ann, who ended up living in the house. The house would remain in the family until 1910, and Schalcosky found that three other families have lived in it since. In September of 2009, the property was purchased by the surrounding apartment complex and could possibly be demolished.

Rumors that the house was haunted have apparently been around for years, but they were not widely circulated. Previous owners and their guests allegedly had strange experiences in the house over the decades and sometimes felt an unnerving presence. The house received public attention when it was featured on A&E's *Paranormal State*. The show reported that a full-body apparition of a woman was seen on two separate occasions, by two different people, in a window on the second floor of the 1910 addition overlooking the back door. The fact that both of the witnesses

to the ghost were black was emphasized because Jacob Weitzel Jr. and his wife were likely abolitionists. It was implied that the house may have been a stop on the Underground Railroad and that there were secret tunnels in the basement. This was used as an explanation as to why the ghost had appeared to the two black witnesses, when most of the residents of the house were white.

While the Weitzels probably were abolitionists, the idea that the house was a stop on the Underground Railroad is much less likely. First, it was not along any of the main routes that the Railroad used in western Pennsylvania. The secret tunnels that were featured on the show were nothing more than old storage areas and crawl spaces that had been covered up over time. They are common in many buildings of that age. Contrary to popular belief, most stops on the Underground Railroad did not have secret tunnels. If they were in a rural area, it was just as easy to hide an escaped slave in a basement or barn if necessary. After the Underground Railroad approach seemed to fall through, the show brought in a psychic to read the house. She sensed disapproval from the spirit with old-fashioned values, possibly over the cohabitation of an unmarried couple.

That being said, the residents of the house and the witnesses to the apparition seemed to be genuinely affected by their encounters with the ghost. One of the men who saw the woman in the window correctly identified Jane Ann Weitzel in an old photograph that was mixed in with other period photographs. Though only two people had seen the ghost, the other residents of the house had heard strange noises in the attic and basement. Some relatives were afraid to stay in the house alone. The psychic brought in by the show allegedly communicated with the spirit of Jane Ann and the ghost and family decided to live peacefully together.

Even though the authenticity of reality shows can be called into question, other witnesses are more reliable. While researching the house, Schalcosky had some unusual experiences of his own. One day, after the house was vacant, he was taking a series of photographs to document the structure for the historical record. Though the house had a strange feeling about it, nothing unusual seemed to occur. Later when he looked at the photographs, he discovered things that he had not seen at the time. When he zoomed in on some of the windows, new details emerged. A photo of the window in which the women had reportedly appeared actually seemed to show the

The Weitzel house in Ross Township, 2010. *Courtesy of the author.*

faint outline of a young woman, though she did not really seem to resemble the older woman described in the show.

A second-floor window on the original part of the house had an even more intriguing image. The picture revealed the faint image of an old man. To Schalcosky, the outline of his nose and face seemed rather distinct. He seemed to be blowing on the glass and fogging it up. Writing was visible in the fogged up area, as if it had been traced by a finger. It appeared to show the letter *M* and possibly a *3*, set against a faint heart shape. Other writing ran up the side of the window but was not discernable in the photograph. During his visit, he had snapped another picture of the same window a moment or two later. The faint image of the man had moved and was now smiling. Others who saw the picture spotted another faint image of a young woman, possibly unclothed. It almost seemed as if the man was pushing her away from the window. Schalcosky then took three sensitive recorders to the house to see if he could capture anything of interest. When played back later, all three had recorded the same message. The first several words were

clear, and then they trailed off. The voice said "Tell them about…" The next words may have been "my symptoms," but they were not clear.

Were ghosts having a conversation that was captured on the recorders? Were they supposed to tell Schalcosky or someone else? During his research Schalcosky discovered that at least six people had likely died in the house and probably several more. If you believe in ghosts, that number of deaths could certainly produce enough spirits to have a conversation. The ghosts that Schalcosky encountered did not appear to be the same ones described in the television show. Perhaps the reason that people have found the Weitzel house to be so eerie is because it has many ghosts. Then again, it has a long enough history for the ghost stories to serve as popular local memories of the old house and its inhabitants. But it seems like something else may be at work as well. The stories of the Weitzel house were never very widespread, and many of those who reported seeing apparitions were unfamiliar with the structure's history. If the house really is haunted, are the numerous and strange ghosts revealing long-forgotten happenings of some kind? Chances are that whatever secrets the Weitzel house holds will disappear with its eventual demolition.

THE GHOST OF THE OLD SHOT TOWER

BEAVER COUNTY

One very old ghost story circulated for decades in the Darlington area of Beaver County. The story dates to the 1800s, and, as with many legends, the facts are hard to pin down. It centers on the old shot tower, which was the nickname of the rather large and tall home–factory of Dr. Bernard Dustin. The building was not a true shot tower, which is a tall structure where molten lead is dropped and hardened into balls (for firearms) on the way down. It was given the nickname because of its unusual size for a personal dwelling. Several dates have been suggested for its time of construction, ranging from 1805 to 1820. The latter seems more likely.

In the 1830s, Dr. Dustin attempted to raise silkworms and turn his tower into a silk factory. Ultimately his attempts to cultivate the worms failed, and he received little financial gain from his endeavor. Around this time, the doctor's daughter, Mary, fell in love with a man from town. For some reason, the legend is never exactly clear as to why; the man had to travel to South America. Mary vowed to wait for his return and promised to be faithful to him. Unfortunately for Mary, she never saw the man again.

In the meantime, her father converted the failed silk factory into a small medical college to train new doctors. Despite the presence of many intelligent and successful young men, Mary never wavered from her promise. Day after day, she would sit in a rocking chair near the window,

waiting for her love to return. She died at a young age, allegedly of a broken heart.

Dr. Dustin died in 1844, and Mary only survived until 1848. For many years after her death strange screams and sobs were reportedly heard inside the building. Her ghost could be seen still rocking in the chair by the window and occasionally roaming the building. The property passed to other owners, and the building's final occupant was George Youtes. He used the old shot tower as a wagon factory. On April 28, 1898, the building suddenly collapsed on itself. Youtes survived only because he had just walked off the front porch. No strong winds were blowing that day, and it was not clear why the structure suddenly came down. It was, however, the fiftieth anniversary of Mary's death.

A SOUTH SIDE SPECTER
ALLEGHENY COUNTY

While writing this book I was told an interesting story about a haunted house on Pittsburgh's South Side. The man who related the story to me and his family wish to remain anonymous, but I can say that the haunting occurred along Eighteenth Street. The family that encountered the ghost moved into the house in the early 1970s. Since that time they have been experiencing strange happenings and have had rather direct encounters with something that seems to defy explanation.

The family believes that the haunting is tied to a tragic death that occurred sometime in the late 1950s or early 1960s. A girl in her midteens who was living in the house was suffering from severe depression. One day she had a breakdown and began to burn her hair. After she had singed most of it off, she went into an upstairs closet and hanged herself. Her ghost remains in the house and has been frequently seen and heard. She seems to appear to men most of the time, but occasionally makes her presence known to women.

This particular ghost has manifested itself in several ways. Footsteps are frequently heard on the second floor when the family is downstairs. They never occur when a live person is on the second floor. Witnesses have also seen the door rattle as if someone were shaking it, but there is no one nearby. The most unique part of this haunting, however, involves a more direct interaction. People who have been sitting in rooms on the second floor of

the house have seen the ghost of the young girl peek around the corner at them from the hallway. This often occurs when their attention is focused on something else, like a television. When they turn to look at her directly, the ghost pulls back around the corner and disappears. There is no place that a person could quickly go without opening a door, walking down creaky steps or running into another family member. The same girl appears every time and does not appear to age. Several of the witnesses have been friends and relatives who did not live in the house and were not aware of the ghost before their sightings. The ghostly girl appears on a fairly regular basis, and the sightings continue to this day. She does not seem threatening and does not create feelings of uneasiness among the family.

One man who lived in the house had another strange encounter in the attic. He entered the room and was reaching for the string that hung down from the light fixture so that he could turn on the light. As he took hold of it, a disembodied left hand swung quickly past his face and disappeared. Though it sounds bizarre, the man insists that it occurred. Did the hand belong to the girl or someone (or thing) else entirely? The family has learned to live with the strange occurrences at the house, but what is really going on? Some of those who saw the ghost were unfamiliar with the tragedy that occurred in the house. Explaining away their sightings is very difficult. It seems that for now, this ghost will continue to make itself at home on the South Side.

THE HAUNTED HOUSE OF HARLANSBURG
LAWRENCE COUNTY

There is an old farmhouse near Harlansburg with an interesting history and some frightening ghosts. To protect the privacy of the family that lives there, the location of the house will not be identified. In the home's early years, it was known to be a safe house for slaves escaping to Canada with the help of the Underground Railroad. The house was located along one of the routes that ran near the New Castle area. It passed through several owners since that time, but not much is known about those who lived there previously. Several additions have been added to the house as well over the years, increasing its size. The current owners have been in the house since the mid-1990s and have experienced numerous interactions with a supernatural presence.

Several members of the family have encountered this presence directly. The wife and mother experienced a couple of incidents in the late 1990s. On one occasion, while she was lying on the bed, she felt someone or something sit down on the other side. She was the only living person in the room. A more frightening apparition appeared to her in the same bedroom in 1999. She looked up from her bed to see a man hanging from the rafters. A noose was clearly visible around his neck, but his head was down and obscured by an old-fashioned, wide-brimmed farmer's hat. The apparition was wearing a long brown coat that stretched almost the whole way down to his feet,

A sketch of the mysterious hanging figure seen in the haunted house of Harlansburg. It was drawn by a member of the family who witnessed the apparition. *Courtesy of the author's personal collection.*

which were covered in old brown work boots. The same ghost was seen by a friend of one of the woman's sons. He was sleeping over at the house when he saw the strange figure walking up the steps from the first floor to the second.

The woman's sons have also had disturbing encounters. They are sometimes uneasy in the home when they feel the presence of the ghost. The oldest son was home alone one day several years ago. When he entered the dining room, he noticed that an incense burner, which hung in the corner, started swinging by itself. There was no draft or breeze, and it was swinging much harder than a draft inside a closed house would push it.

The younger son encountered something that was even scarier. It happened one afternoon when he was a teenager and his parents were not home. The son and his friend that was visiting decided that they would sneak a few drinks while no one was around. The family kept the alcohol on a shelf down in the basement. The son and his friend went down to retrieve a bottle of vodka. Just as the young man was putting his hand on the bottle, his friend tapped him on the shoulder. "What the hell is that?" he said as he pointed to a dark corner in the basement. The son turned to see a pair of menacing eyes staring at them. As fear took hold of them, the son grabbed the vodka and the pair bolted up the stairs. (I can see why they would need a drink after that.) Both sons are now adults, but the brothers are still hesitant to go into the basement.

The family is not sure exactly who or what is haunting their house. A few years ago they had the house blessed by a priest. It lessened the occurrences to some degree but did not eliminate them entirely. The family is sincere in reporting these phenomena. Did the man in the coat and hat take his own life in the house but never really leave? Is there an explanation for the evil eyes in the basement? Whatever is happening at the house, it appears that the answers will remain elusive for now.

GHOST IN THE MILL
ALLEGHENY COUNTY

For decade after decade, the economy of western Pennsylvania was defined and driven by the steel industry. Mills lined the river valleys, smoke clouded the sky and manufacturing was king. It was not uncommon to find two or three generations of a family working in a mill. Steel was as much a part of the region's identity as its rivers and its mix of ethnic peoples. It was the mills themselves, in fact, which were partially responsible for creating the region's multiethnic heritage by providing employment to immigrants. Those days of heavy industry have passed in this region, but the legends and memories of the mills have lived on. Like any other business or institution that is central to the lives of many people, the mills had their own set of folklore and superstitions. They also had a few ghost stories. My personal favorite is the story of the ghost of Jim Grabowski. Grabowski was from one of those immigrant families whose lives, and sometimes deaths, were tied to the mills. He was supposedly killed in an accident in Jones and Laughlin Steel Corporation's Two Shop, once located on Pittsburgh's South Side.

According to the story, Jim Grabowski met his untimely demise one day in 1922 while working near a ladle full of dangerous molten steel. Grabowski tripped over a rigging hose and was not able to catch himself. He plunged head first into the ladle, and his entire body was melted into the steel. The

custom at the time was to take such a ladle and bury it at the dumping ground near Hazelwood, as if you were putting a body in a grave. Sometimes a steel nugget from the vat would be given to the family of the worker. Apparently the ladle that entombed Grabowski never made it there and sat around on the grounds of Two Shop. Forty years later, after Two Shop was no longer used for making steel, some J&L workers cut into an old ladle of steel while they were working on another project. Some believed that when they did, they released Grabowski's ghost. After that, when workers would walk through the old Two Shop, they would report hearing Grabowski's ghostly screams, cries for help and sometimes a "maniacal" laughter. Grabowski's ghost was known to be especially hostile to rigging crews who entered the building because he had tripped on one of their hoses. Allegedly some workers could even see an apparition of Grabowski gliding through the old shop.

George Swetnam, a local historian and folklorist, interviewed J&L workers about the ghost in 1970. One worker told him that about 30 percent of the guys working at that time believed in the ghost. He told Swetnam that during Two Shop's years of operation, from 1905 till 1960, between forty and fifty workers were killed there. The old worker speculated that Jim Grabowski may have just been a fictional character who was created as a representation

A J&L Steel Company rigging crew in the late 1800s. *Courtesy of the Library and Archives Division, Senator John Heinz Pittsburgh Regional History Center.*

of all the deceased workers, but added that he was not working in the shop then so he did not know for sure. It is interesting that even then the worker realized that the story may have been a form of commemoration of the workers who had perished at Two Shop. The memory of their tragic deaths was collectively kept alive through a representative story. Steel mill ghost stories served another purpose when the mills were still around. They were a reminder of the dangerous conditions that surrounded the workers and the need to be vigilant. Even the slightest misstep could result in tragedy.

Swetnam also recorded two poems written about Grabowski's ghost when he was conducting the interviews. The first has been published in several places before, but I will include it here.

> *When you're walking up through Two Shop*
> *You'll know someone is around*
> *If you hear a sort of clanking*
> *And a hollow moaning sound*
> *For the ghost of Jim Grabowski*
> *Who was killed in '22*
> *Must forever walk through Two Shop*
> *Which I will explain to you.*
> *Jim fell into a ladle,*
> *And they couldn't find a trace,*
> *So they couldn't take the body*
> *To a final resting place…*
> *Yes there is a ghost in Two Shop;*
> *I've seen the specter twice,*
> *And you'll stay away from there at night*
> *If you heed my advice.*

The second poem was probably written by the same person, but the workers never verified his identity. As far as I can tell, it only appeared in Swetnam's original article from the *Pittsburgh Press* in 1970.

> *When I saw somebody moving*
> *With a gliding sort of pace,*
> *And my knees began to tremble,*

For this creature had no face!
I was paralyzed with terror,
And I froze as in a dream,
But the creature went right past me,
And walked right through a beam....

MOLL DERRY, FORTUNETELLER OF THE REVOLUTION
FAYETTE AND BEDFORD COUNTIES

Some people said she could see the future. Other people thought that she was a witch. Many early residents of southwestern Pennsylvania believed in her powers. The life of Mary "Moll" Derry was intertwined with the supernatural. Though there are not any ghost stories about Old Moll herself, her abilities led to her involvement in several other ghost stories and supernatural legends.

Moll Derry was probably born sometime between 1760 and 1765, though it may have been as late as the 1770s. Very little is known about her early life, but it has been suggested that she was possibly a German immigrant. She married a member of the Derry family of Virginia and came to southwestern Pennsylvania via Maryland sometime around or shortly after the American Revolution. Her husband may have been Valentine Derry, who is recorded as having moved to Georges Township, Fayette County, in the 1790s, but this has not been confirmed. It appears that her son Bazil was born in Bedford County in 1786, so she was in Pennsylvania by that time. Later she moved to Fayette County, possibly with Valentine Derry, and lived for a while near Haydentown, to the south of Uniontown. Stories told about her over the years place her in a variety of other locations and towns in both Fayette and Bedford Counties. Her reputation as a woman of supernatural power was just as widespread. She was known for predicting the future,

providing healing remedies and flying through the air. Descriptions of her often vary. Some described her as so petite that she slept in a cradle with rockers that ran lengthwise. Other descriptions paint her as a large woman. Derry lived for a long time (some say over one hundred years), so her appearance probably changed over the years. Since she became a legend in her own lifetime, stories about her were often exaggerated and embellished in the retelling. Sometimes Moll Derry was also known as Moll Wampler. There are two different reasons given for the alias. The first was that she was obviously trying to hide her occult activities and sometimes needed a false name for protection. The second possibility is that since so many stories were written about her while she was still alive, the local writers feared that they would anger her if they used her real name. They did not want to be on the receiving end of her magic. It was these same contemporary stories that sometimes referred to her as "the fortune teller of the Revolution."

It is likely that Moll Derry, if she was in fact German, was a practitioner of the Pennsylvania Dutch tradition of folk healing and folk magic known as powwow or hex. In the German language, the practice is known as *brauche*. The tradition was more common in the eastern part of the state, but did come to the west with new German immigrants. Usually the powwower was perceived as a healer of sorts, combining old European and American occult traditions with Christian overtones. Traditionally powwowers provided cures and relief from symptoms, protection from curses (hexes) and evil, located lost objects, animals and people, provided good luck charms and made attempts at predicting the future. These practices were carried out by using charms, amulets, incantations, prayers and ritualized objects. The powwowers were both respected and feared because many were also considered adept at the darker form of *brauche* known as *hexerei*. These hex doctors, or witches, could call on or conjure malevolent forces to inflict harm or curse their enemies. Some would even provide these services for payment. From the tales about her it seems that Moll Derry was skilled at both hex and healing.

The legends make it clear that Moll Derry was not a woman to be crossed. When neighbors angered her, she supposedly made their cattle sick and would even stop their bread from rising. One particular tale was told for many years about Derry and her power to curse. In the mid-1790s, probably about the time of the Whiskey Rebellion, Derry encountered three men who taunted her about her abilities. Derry became angry and told all three

men that they would hang. Her curse started to take effect rather quickly, or at least it seemed. One of the men, whose last name is given either as McFall or as Butler, killed a man in a drunken fight in 1795. He was quickly arrested for the murder, convicted and hanged. McFall/Butler was supposedly the first man to be executed in that manner in Fayette County. The next of the three men to hang was named Dougherty. After murdering a peddler in Fayette County, he fled to Ohio. It was not long before he killed again, but this time he was caught. Dougherty eventually confessed to both murders. Like McFall, he was convicted of the crimes and was hanged in 1800. The third man, whose name may have been Flanigan, learned what happened to the other two men. Remembering old Moll Derry's curse and realizing his fate, he fled to Greene County where he committed suicide. He hanged himself.

Derry, it seems, was skilled at detecting the guilty. In the spring of 1818 or 1819, a peddler was passing through Smithfield and stopped at a tavern. While he was there he met an old acquaintance from New Jersey named John Updyke. The peddler was actually planning to stop and visit Moll Derry to have his fortune told, and Updyke promised to take the man to her. Instead, he led the peddler to his cabin. His friend Ned Casedy (or Cassidy) helped him murder and rob the traveler. The two men carried his body to a nearby millpond under the cover of darkness and tossed it in. Eventually some blood would be found on the trail in the woods, but it could not be linked to the men. After a few days, Casedy's conscience prevented him from sleeping. He decided to visit Moll Derry to see if she could make a potion to help him sleep. When he approached her she supposedly said "Why are you coming to me when your hands are still wet from your dirty work at the millpond?" Casedy was surprised and felt fear as Derry stared at him with her piercing eyes. He quickly turned and walked away. Updyke was not as lucky. At the time of the killing, Moll had an apprentice named Hannah Clarke who lived just up the road from Updyke. Hannah was learning all of Derry's occult secrets. One day a prominent citizen paid her a visit. The man noticed a drawing on the back of her door that resembled Updyke. A nail was in the head. It appeared that it had been tapped in just once, as most of it was still protruding. Hannah explained that if she drove the nail the entire way into the drawing, Updyke would die. Instead she was tapping it in a little at a time so he would suffer and remember his crime. Sure enough,

when the man went to the home of Updyke, he was complaining of a pain in his head. The man said nothing, realizing Updyke's guilt. As the weeks went on the pain grew worse and worse. Updyke could no longer get out of bed and was afraid to be alone. As he lay dying, he confessed to the crime. Not long after, Hannah drove the nail the rest of the way into the door.

One old story that featured Derry and was based on real events was the legend of *The White Rocks*. The fictionalized account was written by A.F. Hill. It tells the tragic story of Polly Williams, a young woman who was killed by the man she had planned to marry in 1810. Polly was a beautiful young woman from a poor family that lived in New Salem. To earn money, Polly worked as a servant in the household of the wealthy Jacob Moss. It was there that she met the man who would kill her. One of the Mosses' neighbors, Philip Rogers, was quickly attracted to the lovely Polly. In 1808, the rest of Polly's family had moved farther west, and everyone assumed that Philip and Polly would soon be married. Unfortunately for Polly, Philip kept postponing the wedding. One day while out for a walk, Polly encountered old Moll near the White Rocks. Moll told her fortune and saw only blood and death. She warned Polly that her fiancé would hurl her down off the ledge onto the rocks below. The encounter disturbed Polly enough that she told Mrs. Moss that she feared that Philip might hurt her. Mrs. Moss told Polly to call off the engagement and stop seeing Philip, but Polly refused. She said that she could not live without him. Late in the summer in 1810, Philip told Polly that he had sent for a minister to marry them up at the scenic White Rocks. Polly put on her best dress and followed Philip into the woods. When they reached the rocks, the minister was not there. It is not clear what had transpired, but the next day her body was found in the hollow below. Her body was examined by a doctor and it was discovered that her head had been struck with a rock before she had been thrown from the cliff. Philip was charged with Polly's murder, but he was able to hire the best lawyers from Pittsburgh, including Senator James Ross. He was acquitted and moved to Greene County. Polly is buried in the Little White Rock Cemetery, and her grave can still be visited today near Fairchance. The White Rocks are supposedly haunted by her ghost. Polly has been seen wandering in the fog on the ledge, waiting for the man who would never marry her. Moll Derry's prediction had come true.

Many more tales would be told of Moll Derry over the years. Sometimes she would be injected into stories that occurred after she was known to have

Senator James Ross defended Philip Rogers in court after Rogers was accused of murdering Polly Williams at the White Rocks in Fayette County. *Courtesy of the Library and Archives Division, Senator John Heinz Pittsburgh Regional History Center.*

died, such as certain fictionalized versions of *The Lost Children of the Alleghenies*. In these stories, which are based on real events that occurred in 1856, Moll Wampler attempts to find the two lost Cox brothers in Bedford County by using a mysterious scrying device known as an Erdspiegel or Erespiegel. This literally means earth mirror. She tells of seeing the children on the ground either dead or sleeping. When they are found dead, an angry mob kills her out of frustration. Of course, that did not really happen because she was dead before the children were even born. (Though in reality, the frozen boys were discovered by a man who had a dream about their location.)

For a long time it seemed as if Moll Derry had eventually just disappeared. Certainly that makes for more of a mysterious story. It appears, however, that she died in 1843. A copy of her will exists in a Fayette County will book. She left her meager estate and property to her children. Even though she died, her legend never really ended. She is forever linked to the ghost of the White Rocks and other supernatural happenings in western Pennsylvania.

THE PHANTOM AT THE POND

ALLEGHENY COUNTY

La Roche College is a small liberal arts college located along Babcock Boulevard in the North Hills of Allegheny County. The school was founded in the early 1960s by the Sisters of Divine Providence. The sisters had the campus laid out and constructed on the land adjacent to their beautiful motherhouse. Originally, the college admitted only women, but by the 1970s men started attending the school, which is now known for its design programs. Since that time the college has developed and grown with the help of the sisters.

Like the other institutions of higher learning that we have already discussed, La Roche also has a few ghost stories that have circulated among its students. One unique story is centered on a shallow, man-made pond that is located along the road in front of the motherhouse. According to the legend, the shallow pond was still deep enough to claim the life of one of the nuns. One of the most commonly repeated versions of the story tells of a blind nun who decided to go out for a walk around the grounds one evening. Though she could not see, she was very familiar with the property and was comfortable walking on her own. As she passed the pond, something tragic happened. Somehow she slipped into the water, possibly hitting her head. Even though it was only a few feet deep, for some reason she was unable to get out. By the time the other sisters realized that she

was missing, it was too late. In the years since the drowning, students have reportedly seen the ghost of the nun repeating her tragic walk near the pond late at night.

The legend was so well-known on campus that in October of 1996, a reporter for the *La Roche Courier*, the student newspaper, decided to investigate its origins. Jennifer Germeyer discovered that the legend of the drowned nun was based on a real event. On March 22, 1949, Sister Mercedes Michel went out for an early morning walk. She would never return to the convent. At 10:00 that same morning, her body was spotted in the pond by a man who was driving past. It was around the same time that some other nuns realized that she had not arrived at the Alpha School (which was run by the sisters) to perform her lunch duties. When the coroner examined her, he concluded that she had died of a heart attack and then fell into the pond. Sister Mercedes was known to have a very nervous personality, and she had been very worried about something in the days before her death. Whatever it was, the stress proved to be too much, and she would never complete her morning walk.

The steeple of the motherhouse of the Sisters of Divine Providence, adjacent to La Roche College. *Courtesy of Angela Wells.*

It is easy to see how the legend would be spawned from this event. The first students of the college in the 1960s were already hearing a secondhand retelling of the sister's death. Over the years details were embellished and the scene shifted from early morning to late at night. After all, a ghost story is always scarier at night. The legend of the ghostly nun kept alive the memory of the tragic accident in a slightly altered form. In a very indirect way, it also serves as a reminder of the sacrifices the Sisters of Divine Providence

The man-made pond located along Babcock Boulevard, in front of the motherhouse of the Sisters of Divine Providence. *Courtesy of the author.*

have made over the years to provide educational opportunities for others. Of course, for those who have claimed to have encountered the ghost over the years, the legend is much more than just a campus memory.

Two of the dormitories at La Roche are also said to be haunted. Both Mahler and Schnieder Halls have allegedly been home to supernatural activity. Ghosts reportedly make strange noises and mysteriously move objects around some of the rooms. I would suggest that there is another word for this type of ghost, and that word is roommate. Usually missing objects have simply been moved by a roommate and the strange noises are merely muffled sounds coming from other parts of the building. In the 1990s, it was rumored that someone had hanged themselves in a room in Mahler Hall. This is not true but is typical of college legends. One would be hard-pressed to find a campus in America without haunted dorm rooms. A few years ago, the rooms in Mahler Hall were blessed by a priest and the incidents seemed to stop—at least until the next batch of freshmen move in.

THE DEVIL TAKES THE WHEEL
ALLEGHENY COUNTY

The following story was related to me by a man with a graduate degree who works in downtown Pittsburgh in a professional capacity. He wished to remain anonymous. His tale is not exactly a ghost story, but it is supernatural and creepy nonetheless, and I decided to include it here.

One day in the spring of 2000, the man was reading on his lunch break. The book that he was beginning was a description of a 1928 exorcism case in Iowa called *Begone Satan*. It was one of the cases that inspired the film *The Exorcist*. The man was interested in the history of religion and was a practicing Catholic himself. That particular day he read a section of the short book that described a car accident that occurred during the case involving the local pastor. Though the pastor was not the exorcist, he had been drawn into the case because it was occurring in his parish.

Early one Friday morning during the twenty-three-day exorcism, the pastor was called to the home of a critically ill woman to deliver last rites. The call was unrelated to the exorcism case. He made it to the house in his car, administered the sacrament and began to drive home. The pastor said several prayers before driving, because the devil or demon that was involved in the exorcism had threatened to harm him when he was not expecting it. The pastor was very familiar with the roads he was driving, but as he approached a bridge, everything in his field of vision disappeared into a

The copy of *Begone Satan* that one man was reading before a strange accident in Pittsburgh's Strip District. *Courtesy of the author.*

black cloud. His car slammed into the rail of the bridge and dangled over the edge. The pastor was able to escape unharmed but was later taunted about the crash during the exorcism by the devil or demon that possessed the woman involved. The evil voice told him that the only reason that he survived was because of the intervention of his patron saint.

The man had to go back to work, so he put the book in his desk. He thought about the incident for a moment. Though he believed in the reality of possession, he thought that perhaps the pastor had just fallen asleep for a moment behind the wheel, especially if he was exhausted from helping with the exorcism every night. Perhaps the demon was merely exploiting the accident to seem more threatening and powerful. He did not think about it the rest of the day, and the entire incident slipped from his mind.

At the end of the workday the man got into his car to go home. Everything seemed fine and the car was handling normally. As he was passing through

Pittsburgh's Strip District, it happened. The steering wheel pulled hard to the left, and the car crossed into the other lane and was heading straight for the side of a nearby warehouse. The man was not going very fast, but it was fast enough to cause injury and damage. He pulled as hard as he could straighten the wheel but it did not seem to budge. It was as if something was pulling on the other side. He was practically standing in his car, using his leg to push off of the side when he finally regained control. The car then overcorrected and headed back out into the street. Luckily, the opposing traffic had a red light at the time; otherwise he probably would have slammed head-on into another car. The man pulled over and tried to figure out what had just happened. He waited for the cars that had stopped and the people who were staring at him to pass.

Then he remembered.

He had doubted the story that he had been reading at lunch. The man said a quick prayer and pulled back out onto the road. He did not have any more problems on the way home. Was the man's subconscious playing a dangerous trick on him? Or was it a far more sinister force that could have cost him his life? The next morning, after arriving at work, he pulled the book out of his desk and took another look at the section that dealt with the crash. Then he read the last section again. The demon claimed to frequently cause accidents with cars to bring people to ruin and cause anger and frustration. The man did not doubt that again or forget the day that the devil took the wheel.

MORE GHOSTLY GRAVES AND HAUNTED CEMETERIES
VARIOUS COUNTIES

This book has covered several haunted locations that included grave sites. While compiling all of these ghost stories I realized that there were dozens of other allegedly haunted graves, churchyards and cemeteries in the region. After all, is there really any better place to interact with the dead than the very spot where they are buried? I have included brief summaries of several of the other haunted grave sites here. Some have more of a detailed ghost story attached to them than others. Burial sites are natural places for ghost lore to thrive and are often legend-trip destinations because of their accessibility and eeriness.

Our first stop on our tour of ghostly graves is the B.W. Snyder Cemetery in Moraine State Park, Butler County. The cemetery is one of several in the park and is located along Burton Road. A stone wall surrounds the small cemetery. Legend says that the ghost of one member of the family, Conrad Snyder, haunts his burial site. A strange green light or aura and a mysterious fog have been reported around his grave. For years it has been said that a pair of glowing red eyes can be seen in the darkness, and that they will follow late-night visitors through the cemetery.

Bright Cemetery in Oakmont, Allegheny County, is rumored to be haunted by a Civil War veteran. Michael Bright and his family were some of the first people to settle in Oakmont. Years later, several of his grandchildren fought

in the Civil War and were killed. One grandson, Adam, was captured and died in the horrible disease-ridden conditions that existed in Andersonville Prison in Georgia. He was buried there among the graves that are now part of the national park. His family erected a tombstone for him in Bright cemetery next to his father, but they were never able to bring back his body. Supposedly, on foggy days, his ghost can be occasionally seen walking among the graves of his dead relatives.

A rather strange grave reportedly exists in Madonna Cemetery in New Castle, Lawrence County. Though I have seen no definite confirmation that grave and gravestone exist, a rather detailed legend-trip ritual has developed around it. Assuming that the entire thing is not a hoax, one would have to look for a tombstone with a picture of a man on it that has one white hand and one black hand. The ritual can only be performed on Halloween. First the stone must be covered with a white sheet. When the visitor knocks on the tombstone three times, the ghost of the man will appear behind him. Perhaps the reason that this legend has never been confirmed is that everyone that would care to check on the story had something better to do on Halloween.

Another haunted cemetery is located near a swamp in the Turkey Hill section of Shenango Township, Lawrence County. The Tindall Family Cemetery contains the graves of some of that area's first settlers. The earliest burials date to 1795. It also allegedly contains the grave of a witch named Mary Black. Dates given for her death have ranged from 1796 to 1888. Mary's grave is separate from the rest of the burials. Her ghost story is a variation of the classic Bloody Mary legend. Supposedly if you visit her grave and say her name three times, she will rise from the grave that night while you are at home sleeping and claw your face with her hideous long nails. Over the years the cemetery has suffered from vandalism, so, if you visit, please be respectful of the graves.

In Pitcairn, Allegheny County, there is a small abandoned cemetery located off of Hillside Avenue. Vague rumors have circulated that Fair View Cemetery is haunted. A mysterious fog blankets the grounds some nights and does not seem to move with the wind. Sometimes the apparitions of those who are buried there will briefly appear. Most of the graves seem to date between the 1850s and the 1950s. The cemetery and the surrounding hillsides were allegedly once used as a meeting area for the Ku Klux Klan in the 1920s.

Hoffman Cemetery, near Smithton, Westmoreland County, is home to a glowing tombstone. This interesting stone glows very brightly from a distance (several hundred yards), but its light fades as you approach it. None of the surrounding stones glow or give off any light. After they heard the story, several friends of mine went to the cemetery numerous times to try to solve the mystery of the stone. They suspected that the stone may be reflecting a light in the distance, but there did not seem to be any. The tombstone itself was made of pink marble and was not in any way unique in construction. Eventually they found the real source of this legend, or at least they think they did. There was one light attached to a building over the hill that, when blocked, seemed to stop the stone from glowing. It was apparently reflecting the light from the strange angle.

Restland Cemetery, near Monroeville, Allegheny County, was long reported to be the home of a very active ghost called Roamin' Rosie. She supposedly died around 1900. She could frequently be seen walking the cemetery grounds. If you followed Rosie, she would walk to her grave and vanish. Her large grave marker, which included a full-sized statue of her, was removed several years ago after it was heavily damaged by vandals. Rosie has not made as many appearances since.

Finally, the Beulah Church Cemetery located near Apollo, Armstrong County, also has ghosts. During the late 1800s, it became the final resting place for several Civil War soldiers and victims of tuberculosis, the white plague. On nights when the moon is bright, misty white shapes have been reported that slowly move among the graves. The church that accompanied these graves apparently burned down decades ago.

MORE HAUNTED COLLEGES AND UNIVERSITIES
VARIOUS COUNTIES

Just like the cemeteries, it seems as if every local college and university has a ghost story. Several have been discussed already, but I would like to include a few more here. Colleges traditionally have enormous amounts of folklore surrounding them. That folklore carries traditions, provides warnings and perspective and transmits institutional history. It also reflects stresses, fears and challenges of college life that are experienced by young adults who are on their own for the first time. Ghost stories regularly play a large part in the folklore. The stories collected here are just a sampling.

The president's house at Washington and Jefferson College is alleged to be haunted by the ghost of a dead Confederate soldier. The legend claims that he was captured and hanged in what is now the front yard. Supposedly the ghost has even been seen by some of the college's former presidents. The problem with the story is that the old Victorian house was built in 1892 and was not there during the Civil War. In the unlikely event that a Confederate soldier was hanged there, it happened in a field, not a front lawn. McMillan Hall is also allegedly haunted. The original part of the building was completed in 1794, and it is one of the oldest academic buildings still in use in the United States. A ghost in colonial-era clothing, nicknamed Abigail, has been seen and heard sweeping the halls. She has also been blamed for doors mysteriously closing on their own. Though there are offices in the

building now, it once housed students. Abigail could not have been a student (the college only accepted men at the time) but perhaps she is the ghost of a woman who helped take care of the building and its residents. Or maybe her alleged appearances are merely a reminder of the long history of the venerable building.

At Slippery Rock University, the Miller Auditorium is said to harbor a ghost. Luckily it is a friendly one. The spirit at the auditorium is thought to be its longtime patron, Emma Guffey Miller. Costumes disappear and reappear, loud noises are heard and lights turn themselves on and off. Sometimes a very brief glimpse of a mysterious figure is seen. Emma is said to be especially active in the costume room. The legend of her ghost has spawned a tradition among those who act in the auditorium. For years, a baby doll was hidden onstage during each play or performance. For some reason it was believed that this would prevent Emma from causing mischief during a show. Only the head of the doll remains today, but the tradition is still upheld.

Seton Hill University has several ghostly tales of its own. An unlikely tale centers on the Administration Building, where many years ago a nun passed out in the basement. One of the custodians allegedly believed that she was dead and accidently had her buried alive. The story says that you can still hear her ghost pounding on the lid of her casket, trying to get free. Needless to say, there are many things that are unbelievable with this legend, not the least of which is a custodian with the authority to order burials of people that he decides are dead. St. Joseph's Chapel is also haunted by the ghost of a nun who appears near the organ. A young woman allegedly fell out of the bell tower (or committed suicide), and her ghost appears in the tower and courtyard below. Students in Brownlee Hall, a freshman dorm, reportedly hear footsteps in the hallways and outside their doors when there is no one around. Rumor has it that in one of the rooms, the shadow of a student who hanged herself can sometimes be seen on the wall.

Community College of Allegheny County has its own ghost, too. The mansion that once belonged to Alexander Byers, now known as Byers Hall, is the location of the haunting. Byers had made a fortune in the manufacture of iron and iron piping by 1900. It was enough to own the large house on Ridge Avenue, also known as Millionaires Row. His daughter and her husband lived in one wing of the mansion with their young daughter. Unfortunately,

in 1902, the German nanny who was watching the little girl fell asleep. The child crawled out onto a skylight near the inside stairwell. It could not hold her weight, and the child plunged to her death. The distraught nanny soon hanged herself in the same stairwell, unable to live with the guilt. Written in dust on the nearby window ledge were the words "Entschuldigan Sie mir bitte" that mean "Please forgive me." Over the years, both the nanny and the daughter have been heard and seen walking and crying in the stairwell. Sometimes a strange thud has been reported, as if the girl has fallen to the ground again. Supposedly the nanny's message reappears when the window ledges get dusty, even after they are wiped away dozens of times. The skylight was removed around 1990, and the ghost of the little girl stopped appearing. The nanny is still seen though, sobbing in the stairwell where she made one tragic mistake.

CONCLUSION

So what can we learn from this collection of hauntings? Many of these ghosts seem to be explainable, but others are not. As I stated at the beginning of the book, it was not my intention to prove or disprove the existence of ghosts. Rather, I hope that I have demonstrated that at least some of the legends have subtler and more complex meanings. Maybe these places are haunted. Certainly many people genuinely believe that they have had encountered the supernatural. I, too, have experienced things that remain unexplained. However, I think that when we really examine these legends, we have the opportunity to learn more about our history, our fears and ourselves. Ultimately, these hauntings tell us more about the living than they do about the dead.

SELECTED BIBLIOGRAPHY

Archival Materials and Interviews

Ault v. Pennsylvania Railroad Co., 381 Pa. 496 (1955).
Charles M. Stotz Papers, MSS 21. Library and Archives Division, Senator John Heinz Pittsburgh Regional History Center.
Cobbey, Brett. Interview with author about haunted Quaker church, January 5, 2010.
Dixmont State Hospital Records, MSS 329. Library and Archives Division, Senator John Heinz Pittsburgh Regional History Center.
George Swetnam Papers, 1999.0039. Library and Archives Division, Senator John Heinz Pittsburgh Regional History Center.
Hassett, Michael. Interview with author about Lawrence County urban legends, January 22, 2010.
Schalcosky, John. Interview with author about Weitzel House and Evergreen Hotel, January 23, 2010.
Simkins, Dan. Interview with author about haunted Quaker church, December 31, 2009.

Bibliography

Articles

Ackerman, Jan. "A Mental Hospital's Breakdown." *Pittsburgh Post-Gazette*, April 20, 2003.

Arensberg, Charles C. "Evergreen Hamlet." *Western Pennsylvania Historical Magazine*. 38, no. 3–4 (1955): 117–133.

Banks, Gabrielle. "Evergreen's Colorful Past." *Pittsburgh Post-Gazette*, May 25, 2006.

Barcousky, Len. "Evergreen Hotel in Ross to be Sold by State." *Pittsburgh Post-Gazette*, November 5, 2009.

———. "Ross Landmark sells for $140,000." *Pittsburgh Post-Gazette*, November 12, 2009.

Barnes, Jonathan. "A Colorful and Sordid History—The Evergreen Hotel." *In Ross Township*, Winter 2009.

———. "Namless Flu Victims not Forgotten: Concern about Avian Flu has Sparked New Interest in Those Who Died in 1918 Outbreak." *Pittsburgh Post-Gazette*, December 29, 2005.

Beatty, Jim. "Workmen Renovating Landmark at College." *Catholic Accent*, January 15, 1976.

Bedford Gazette. "Two Killed in Crash," May 27, 1952.

Beveridge, Scott. "A Case of the College Creeps." *The Observer-Reporter*, October 28, 2009.

Bigley, Natalie. "Late at Night, Edgar Allan Poe Relative Might Haunt Cathedral." *The Pitt News*, October 29, 2009.

"Bitter Fight on Restaurant." *The Pittsburgh Press*, April 9, 1905.

"Burglars Had Planned Well." *The Pittsburgh Press*, April 28, 1902.

Clearfield Progress. "Auto Crashes Into Guard Rail, Drops 90 Feet, Two Dead," April 6, 1937.

Copeland, Dave. "Thrill-Seekers Hunt Ghosts in Dixmont State Hospital." *Pittsburgh Tribune-Review*, August 25, 2003.

Farabaugh, Jason. "Looking Inside Sauerkraut Tower." *Review*, February 24, 1995.

Ferguson, Russell J. "Albert Gallatin Western Pennsylvania Politician." *Western Pennsylvania Historical Magazine*. 16, no. 3 (1933): 183–195.

Germeyer, Jennifer. "Rumors of Drowning are True." *La Roche Courier*, October 31, 1996.

Bibliography

Heart to Heart: Newsletter of the Benedictines of St. Vincent Archabbey. "Restoration Work Begins on Historic Gristmill," Winter 1998.

Indiana Progress. "Keystone Cullings," September 30, 1891.

Johnson, L.A. "It's Official: Ghosts Haunt Slippery Rock Auditorium." *Pittsburgh Post-Gazette,* March 20, 2009.

Lacey, Patrick. "The Old Sauerkraut Tower." Unpublished, no date.

Machosky, Michael. "Seeking the Paranormal." *Pittsburgh Tribune-Review,* October 18, 2005.

McKay, Gretchen. "Does Pitt's Cathedral of Learning Host a Ghost?" *Pittsburgh Post-Gazette,* October 31, 2009.

Morning Herald–Evening Standard. "New Bridge is Ordered," November 7, 1974.

Moseley, Edwin M. "Washington And Jefferson Colleges: A Microcosm Of The Civil War." *Western Pennsylvania Historical Magazine.* 45, no. 2 (1962): 107–113.

New Castle News. "Beaver Span Plans Ordered," May 29, 1971.

———. "PA News Observes," December 13, 1954.

Pittsburgh Post Gazette. "Professor Dies in Leap from 13th Floor of Pitt," August 20, 1959.

Raffaele, Elizabeth. "Haunted Fisher Hall Attracts Suspicion and Eerie Caution from Employees." *Duquesne University Times,* October 25, 1999.

Review. "The Sauerkraut Tower," March 21, 1960.

Reynolds, James C. "Haunted Houses: Some for Real, Some Pretend." *Valley Tribune,* October 31, 1987.

Schalcosky, John. "Voices From the Past?" *Ross Record,* January–March 2010.

Scott, Rebekah. "Here: In Latrobe." *Pittsburgh Post-Gazette,* January 18, 2004.

Smith, Craig. "Ghost Hunters Plan Spirited Investigation." *Pittsburgh Tribune Review,* February 23, 2009.

Sostek, Anya. "Paranormal Investigators Scrutinize Slippery Rock Theatre; University Staff Have Haunting Suspicion." *Pittsburgh Post-Gazette,* March 1, 2009.

Swetnam, George. "The Ghost in St. Vincent Archabbey." *Pittsburgh Press,* April 7, 1968.

———. "The Ghost of Two Shop." *Pittsburgh Press,* September 6, 1970.

Watson, Kathy. "Sophie's Ghost." Unpublished, 2000.

Wehrheim, Lizz. "Ghosts Spook LRC Students in Mahler Hall." *La Roche Courier,* October 31, 2003.

Bibliography

Wilson, Andrew. "High Achievers: Dixmont's History Helps Carlow Graduate Build Reputation as a Documentarian." *Carlow Journal*, December 2006.

Winner, John W. "The Depreciation and Donation Lands." *Western Pennsylvania Historical Magazine*. 8, no. 1 (1925): 1–11.

Books

Alberts, Robert C. *Pitt: The Story of the University of Pittsburgh 1787–1987*. Pittsburgh: University of Pittsburgh Press, 1986.

Bausman, Joseph H. *History of Beaver County Pennsylvania and Its Centennial Celebration*. New York: Knickerbocker Press, 1904.

Bergland, Renee L. *The National Uncanny: Indian Ghosts and American Subjects*. Hanover, NH: University Press of New England, 2000.

Bronner, Simon. *Piled Higher and Deeper: the Folklore of Student Life*. Little Rock, AR: August House, 1995.

Buck, Solon J. and Elizabeth Hawthorn Buck. *The Planting of Civilization in Western Pennsylvania*. Pittsburgh: University of Pittsburgh Press, 1939.

Davies, Owen. *The Haunted: A Social History of Ghosts*. London: Palgrave MacMillan, 2007.

Ellis, Bill. *Aliens, Ghosts and Cults: Legends We Live*. Jackson: University Press of Mississippi, 2001.

———. *Lucifer Ascending: The Occult in Folklore and Popular Culture*. Lexington: University Press of Kentucky, 2004.

Frazier, Heather. *Pittsburgh's Ghosts: Steel City's Supernatural*. Atglen, PA: Schiffer Publishing, 2008.

Hufford, David. *The Terror That Comes In the Night: An Experience-Centered Study of Supernatural Assault Traditions*. Philadelphia: University of Pennsylvania Press, 1982.

Kline, Omer U., O.S.B. *The Saint Vincent Archabbey Gristmill and Brewery 1854–2000*. Latrobe, PA: Saint Vincent Archabbey, 2000.

Kriebel, David W. *Powwowing Among the Pennsylvania Dutch: A Traditional Medical Practice in the Modern World*. University Park: Pennsylvania State University Press, 2007.

Bibliography

Mogus, M.A., Ed Kelemen and Brendan Kelemen. *Weird West Overton.* Scottdale, PA: West Overton Village, 2008.

Nesbitt, Mark and Patty A. Wilson. *The Big Book of Pennsylvania Ghost Stories.* Mechanicsburg, PA: Stackpole Books, 2008.

Oetgen, Jerome. *An American Abbot: Boniface Wimmer, O.S.B., 1809–1887.* Revised Edition. Washington, D.C.: Catholic University of America Press, 1997.

Stotz, Charles Morse. *The Early Architecture of Western Pennsylvania.* Pittsburgh: University of Pittsburgh Press, 1936.

Swetnam, George. *Devils, Ghosts, and Witches: Occult Folklore of the Upper Ohio Valley.* Greensburg, PA: McDonald / Sward Publishing, 1988.

———. *Pittsylvania Country.* New York: Duell, Sloan & Pearce, 1951.

Switala, William J. *Underground Railroad in Pennsylvania.* Mechanicsburg, PA: Stackpole Books, 2001.

Trapani, Beth E. *Ghost Stories of Pittsburgh and Allegheny County.* Reading, PA: Exeter House Books, 1994.

Tucker, Elizabeth. *Campus Legends: A Handbook.* Westport, CT: Greenwood Press, 2005.

———. *Haunted Halls: Ghostlore of American College Campuses.* Jackson: University Press of Mississippi, 2007.

Walker, Barbara, ed. *Out of the Ordinary: Folklore and the Supernatural.* Logan: Utah State University Press, 1995.

Wollman, David H. and Donald R. Inman. *Portraits in Steel: An Illustrated History of Jones and Laughlin Steel Corporation.* Kent, OH: Kent State University Press, 1999.

Vogl, Father Carl. *Begone Satan!* Reprint. Charlotte, NC: TAN Books, 2009.

Videos

The Dixmont State Hospital: A Historical. DVD, directed by Kate Guerriero. Stargazer Video Productions, 2006.

Paranormal State. "The Woman in the Window," DVD. A&E, February 11, 2008.

Bibliography

Websites

Gostkowski, Drenda. "Winfield Township's 1918 Influenza Mass Grave Site." January 10, 2010. Saxonburg Local History. http://www.saxonburglocalhistory.com/Winfield.html.

Holohan, Meghan. "Standing Tall." December 8, 2009. Pitt Magazine. http://www.pittmag.pitt.edu/fall2003/feature4.html.

Lyons, Joan. "Providence Meeting House." November 16, 2009. Perryopolis.com. http://www.perryopolis.com/providence.shtml.

———. "Providence Meeting House (Quaker Church) Cemetery List." November 16, 2009. Perryopolis.com. http://www.perryopolis.com/providencecem.shtml.

ABOUT THE AUTHOR

Thomas White is the university archivist and curator of special collections in the Gumberg Library at Duquesne University. He is also an adjunct lecturer in Duquesne's History Department and an adjunct professor of history at La Roche College. White received a master's degree in public history from Duquesne University. Besides folklore and western Pennsylvania, his areas of interest include public history and American cultural history. He is the author of *Legends and Lore of Western Pennsylvania* and *Forgotten Tales of Pennsylvania*, also published by The History Press.

Visit us at
www.historypress.net